D0488185

JOHN COLE

THE ENDURING NORTHWEST LANDSCAPE

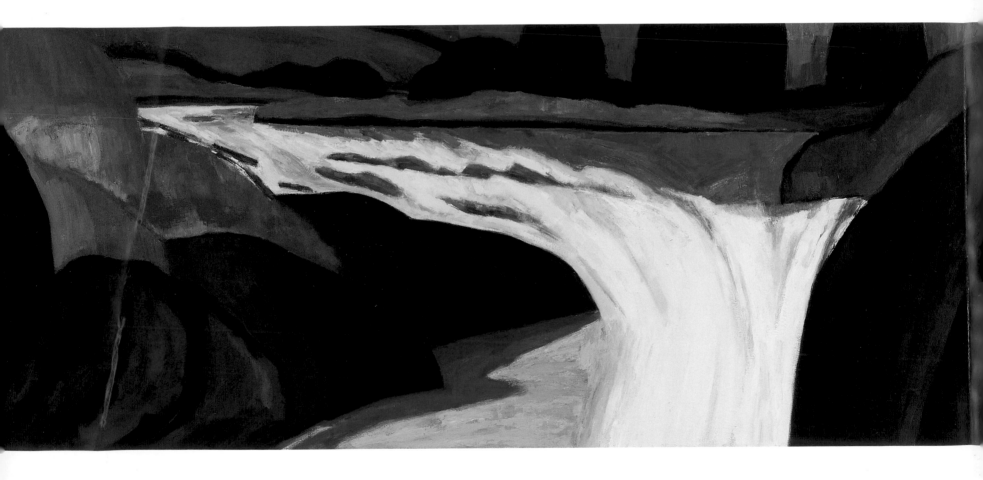

JOHN COLE

THE ENDURING NORTIIWEST LANDSCAPE

Essay by Deloris Tarzan Ament

WHATCOM MUSEUM OF HISTORY & ART
BELLINGHAM, WASHINGTON

DISTRIBUTED BY THE UNIVERSITY OF WASHINGTON PRESS

©2003 Whatcom Museum of History & Art

121 Prospect Street
Bellingham, Washington 98225

This catalogue was published in conjunction with the exhibition *John Cole: The Enduring Northwest Landscape,*
June 8–October 5, 2003.

Library of Congress Control Number: 2003105665
ISBN 0-938506-09-9

Edited by Q.E.D., Seattle
Designed by Phil Kovacevich
Printed in Canada

Cover: *Eagle Lake* (detail), 2000, oil on linen, 24 x 30 in., collection of Jill and Edward Rosenthal
Back Cover: *Steamboat Creek,* 1998, oil on canvas, 30 x 36 in., collection of Eric Peterson and Barbara Pomeroy
Title page: *Sherars Falls,* 1999, oil on linen, 50 x 120 in., collection of Brad Lovering and Valarie Baker
Page 112: *The Painter's Studio,* 1965, oil on paper, 4 ⅝ x 5 ⅝ in., collection of the artist

All photographs by Spike Mafford except the following:
pages 14, 15, 16, 18, John Cole; pages 106, 107, Mary Randlett; page 105, Al Sander;
pages 17, 20, 96, 97, 98, 99, Bill Wickett

Distributed by University of Washington Press
P.O. Box 50096
Seattle, WA 98145

CONTENTS

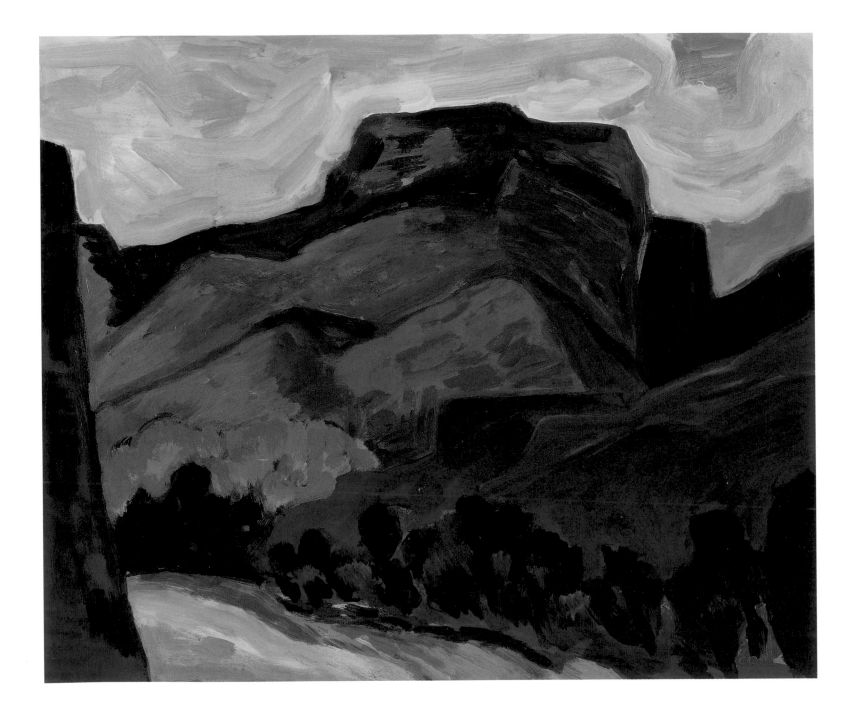

This is the type of exhibition we especially enjoy presenting at the Whatcom Museum of History & Art. It addresses the Museum's mission—to provide leadership in the fields of art and history in the Pacific Northwest—but is even more pertinent in that John Cole has lived and worked in Bellingham since 1975. We are committed to supporting local artists and are proud to be a community resource, helping visitors experience many different kinds of artwork. It is a pleasure to be presenting this overview of Cole's work, which so eloquently captures the spirit of the regional landscape.

Organizing a major exhibition and catalogue is never an easy task, and only through the dedication and assistance of many people can it be successful. We are grateful to the collectors who have generously lent their paintings to the exhibition. It would be impossible for us to present such a rich, engaging selection of works—as a group—without the lenders' willingness to part with their much-loved treasures for these many months. A special thanks to Lisa Harris and the staff at her gallery, whose knowledge and expertise of Cole's work have provided invaluable assistance throughout this project. I would also like to thank Lisa Van Doren, the Curator of Art for the Museum, for the excellent job she has done in assembling the work, shepherding the catalogue, and presenting the art of John Cole for the rest of us to enjoy. Other staff of the Museum played key roles as well, including Scott Wallin,

Exhibition Designer, who conceived the idea for this exhibition; Kathleen Iwersen, Development Associate, for her tireless fundraising efforts; and Deanna Zipp, whose all-around wizardry helped in countless ways.

Finally, we appreciate the support of the City of Bellingham, the Washington State Arts Commission, and the National Endowment for the Arts, as well as the many individuals and businesses who have made contributions to the exhibition and catalogue. Without the support and generosity of these sponsors, this project would not have been possible.

Thomas A. Livesay
Director

FOREWORD

Whitehorse Canyon
1991
Acrylic on paper
20 x 24 in.
Private collection

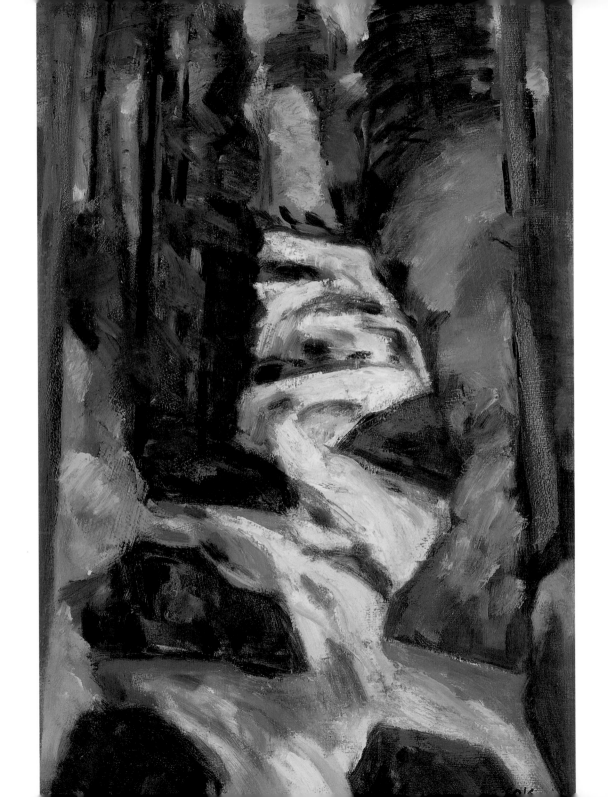

For more than thirty years, John Cole has been painting the Northwest landscape. The works of art gathered together for this exhibition represent his journeys into the natural beauty of Washington, Oregon, Alaska, and British Columbia. Since drawing and painting directly in nature is an integral part of Cole's process, the paintings seen here also represent countless hiking, fishing, and camping trips into the wilderness, searching for waterfalls, lakes, and rivers.

There is something particularly "Northwest" in this unmediated approach to painting the landscape. *Plein air* painting—working directly in nature—produces works of art possessing energy and immediacy not easily replicated in the studio. Though full of rewards, this practice has its share of discomfort and risk. While painting the vibrant, rushing Phillips Creek, Cole got caught in a storm and drifted for miles in his boat, unable to find a safe place to land. Today he laughs that he was most worried about saving the painting, but in truth, the natural beauty he seeks is accompanied by nature's power and unpredictability. Cole's bold color combinations and abstracted, simplified shapes convey the essence of the landscape, but his adventurous spirit is also a key component in the success of the paintings presented here.

Many people helped make this exhibition and catalogue possible. I am continually impressed by the hard-working staff at the Whatcom Museum of History & Art, whose creativity and energy seem to magically turn challenging ideas into enticing exhibitions. Lisa Harris' extensive knowledge and perceptive insights into Cole's career helped provide focus for this exhibition and catalogue. Her unwavering support of and dedication to Cole and his work for the past fifteen years has been instrumental to his growth and success. Our appreciation is further extended to John Cole's wife, Lucille, who nearly twenty years ago convinced him to quit his day job and pursue painting full-time. Thanks also to Deloris Tarzan Ament, whose insightful catalogue essay informs the exhibition, to photographer Spike Mafford who skillfully documented many of the works in this publication, and to Phil Kovacevich for his elegant design of this catalogue.

Finally, I would like to thank John Cole for the many years he has dedicated to the practice of his art. The unanimous enthusiasm and praise I heard from the collectors and artists I spoke with while organizing this project reflect the appreciation and respect many feel for his work. The long hours and careful consideration he has given to this exhibition and catalogue while still maintaining his vigorous schedule of painting both outdoors and in the studio is truly remarkable.

The natural beauty of the Pacific Northwest has attracted many artists through history. As an institution situated very near much of the rugged natural beauty Cole depicts, the Whatcom Museum is especially pleased to present John Cole's vision of this enduring Northwest landscape.

Lisa A. Van Doren
Curator of Art

PREFACE

Phillips Creek
1992
Oil on paper
24 x 16 in.
Collection of the artist

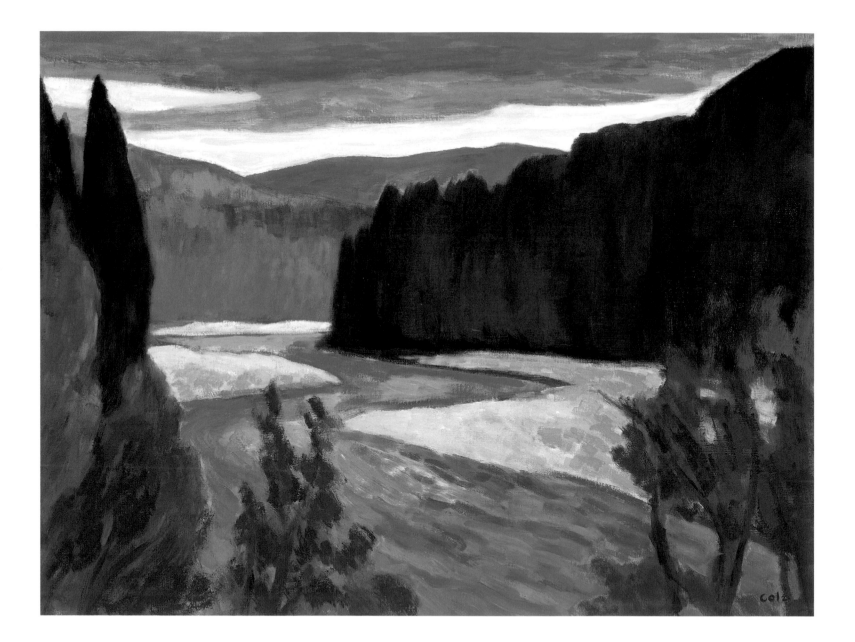

THERE IS NO SOFTNESS TO A JOHN COLE LANDSCAPE. Trees, mountains, and water are laid out in blocks of color as crisp-edged as those in a stained glass window, while the sky, which often sings with unexpected color, refuses to recede into the background. You are unlikely to find a field of wildflowers among his canvases, nor an apple tree freighted with ripe fruit.

His eye goes to the dramatic rather than the obviously pretty. He seeks out scenes with strong bones—that is, with elements such as tall trees, mountains, and moving water. But the landscape he paints is not exactly the scene anyone else might see from the same spot.

"In making a painting, I make it purposely not a copy of what's in front of me. To do it exactly would be a boring exercise. What's inside me has to come out."[1] To find his singular point of view, he sights fragments of his surroundings with a view card to frame parts of the scene, searching for an aspect of it that makes a good composition. But even the chosen part is not exactly what gets painted. "When I set up my easel and get ready to do a scene, the trees in the background may be monotonously spiky. Without the artistic license I take in changing them, brushing up some of them, eliminating others, there would be no painting."

Whether or not a waterfall takes center stage, as it does in dramatic canvases such as his 1992 *Waterfall No. 8* (page 64) and the 1999 *Sherars Falls* (page 40), water is often central to the scene.

Cole affirms, "Water is the most important element in most of my paintings. Early on, someone said to me, 'You don't want to do waterfalls; they're such a cliché.' That made me really interested, to see what I could do with them."

The earliest waterfall in the exhibition, his first painted version of Sherars Falls, dates from 1991. The water cascades like a length of draped silk taffeta, pushed between the dark bite of rocks. His 2002 *Waterfall* (page 74) is more painterly. An additional decade of painting has given him a more decisive hand. In the later work, the waterfall itself fills the picture plane. No sky, no framing hills, no background at all—just the crash of water over rocks.

Thirty years ago, John Cole was an unknown painter. Today, he ranks as one of the leading landscape artists of the Northwest. Over the course of those years, his focus has tightened, his colors become more lush, his brushwork more bold, the shapes of trees and rock more crisp and sure. He is a painter to be reckoned with. Yet until he was past forty, a career in art seemed a distant dream. His story is one to give heart to those who feel a dream postponed is a dream lost.

Born in London in 1936, the youngest of nine children, John Cole spent many of his early years in the belief that being bombed with regularity was a normal way of life. When World War II began, his neighborhood was one of the first to be hit by German bombers. The Coles moved from their destroyed home, but the move brought

JOHN COLE
A PASSION FOR LANDSCAPE

Deloris Tarzan Ament

Nooksack River
2000
30 x 40 in.
Oil on linen
Collection of Polly and David McNeill

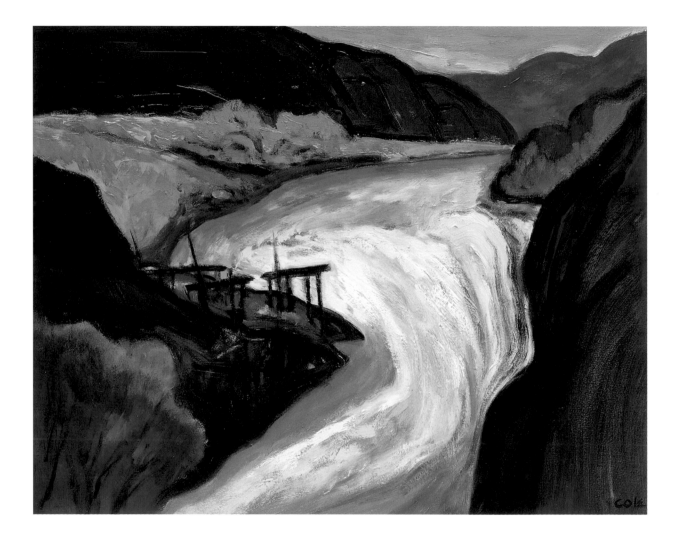

Sherars Falls
1991
Oil on paper
16 x 20 in.
Collection of Anita Baker

small relief, since their new locale was an industrial area that was a repeated target of air attacks.

Because Stuka dive bombers so often took out schools, Cole's early schooling was sporadic. He spent a good deal of time alone while his parents worked. "I played school, and I was both teacher and student. I made up games and played both sides." Such early experiences in creating his own amusement and exploring his own interests strengthened his imagination—a solid asset for his later profession as an artist, if an emotionally costly way of coming to it.

When the war ended and the children of London returned to school, it was Cole's good fortune to have an art teacher who recognized his early ability. In addition to encouraging him to draw and paint, he took Cole to the Tate Gallery and other London museums to see the work of master artists. The encouragement bore fruit. At age thirteen, Cole painted a landscape titled *The Cornfield* that so impressed his teacher that he took it to show at the Royal Academy of Art. Cole was awarded a scholarship for study at the Academy.

It was as good as a trip to the moon for a poor boy from the working class. Too good. Cole was never to use the scholarship. His parents, both untutored, didn't understand what it meant to study at the Royal Academy of Art. They could see little value to their son in learning to paint and draw. They thought it far more important that he begin to earn a living. Londoners were still suffering privations in the aftermath of the

war, and times were far from easy. Cole's older sister had moved to New York as a G.I. war bride, and her parents decided to make the move as well. They brought John to America.

Cole was fifteen when he moved to Long Island, where he finished high school. He took some classes at Pratt Institute, and was a regular at the open painting class on Friday nights. He and the other students sold their still-wet canvases for twenty-five dollars whenever interested buyers appeared.

Everything changed in 1958 when Cole, still a registered alien in the U.S., was drafted. "My choice was to serve in the U.S. Army or be sent back to

Above: John Cole, age 6, in England, 1942

Left: John Cole in Rome, 1960

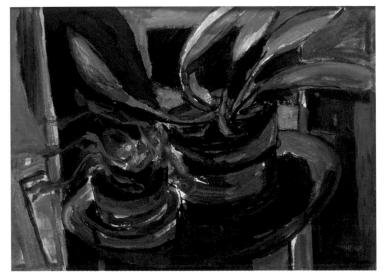

Still Life with Orchids
1977
Acrylic on paper
13 ½ x 18 ½ in.
Collection of Mary and Albert
Froderberg

England," he said. "I decided that since my father had been a sailor, I'd uphold the family tradition. I enlisted in the Navy." Cole's father was a lighterman, part of the crews who brought ships' cargoes up the estuary to the loading docks of London. "It was a great thing to be a lighterman," Cole explained. "Once a year, lightermen get to row the Queen's barge up the river."

Cole's four-year career in the U.S. Navy took him considerably farther afield than his father had ever been. The Navy sent him to electrical school, then assigned him to a serve aboard the U.S.S. Mount McKinley, a communications ship. He recalls it as "350 feet long, and roly-poly with a lot of communications gear up top." The ship took him on three tours of the Mediterranean Sea, and back across the Atlantic to Newfoundland, and to the Panama Canal. Halfway through his tour of duty, he was served with an arrest warrant for failing to appear at his local post office to fill out the necessary papers required of resident aliens each year—a warrant that was quickly dismissed.

He got out of the Navy in 1962 with thirty dollars in his pocket and nowhere to go, since his parents had returned to England. But one of his brothers was living in Florida. Cole joined him there, and went through the process of becoming a U.S.

citizen. He soon moved to southern California and took a job with a utility company. Not until then did he pick up a brush again and return to painting. His boyhood dream of being a painter seemed to have evaporated. He felt his art had no direction other than being an enjoyable pastime. But another twist of fate awaited him.

He traveled to the Pacific Northwest on vacation in 1967, and was so struck by the natural beauty of the area that he decided to move. His specialized training as a meter technician was a prized skill. He relocated to Longview, where he took a job with the Public Utilities District. He had been in the Northwest scarcely more than a year when, in 1969, he decided to take a year off work to focus on painting. During that year, he met Lucille, whom he took to England to meet his family, and who later became his wife. At the end of that year he moved to Bellingham to work for Puget Power.

During the next ten years, Cole's vocation as a painter came into full flower. He and fourteen other Bellingham artists formed the Magnolia Gallery in the Garden Street Methodist Church. The pastor, Cole says, "opened his heart and his building to us." He was nearly fifty before he gained enough confidence in his abilities to quit his job at Puget Power and become a full-time artist.

Although he has studied for brief periods of time with a number of people, Cole considers himself to be basically a self-taught artist. His style was

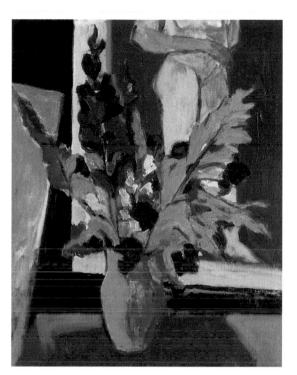

Interior/Studio
1994
Oil on linen
20 x 16 in.
Collection of Renata E. Cathou

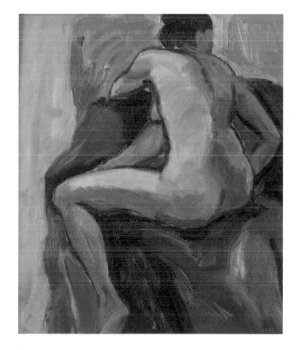

Interior with Flowers
1994
Oil on linen
24 x 30 in.
Collection of Alice and Don Porter

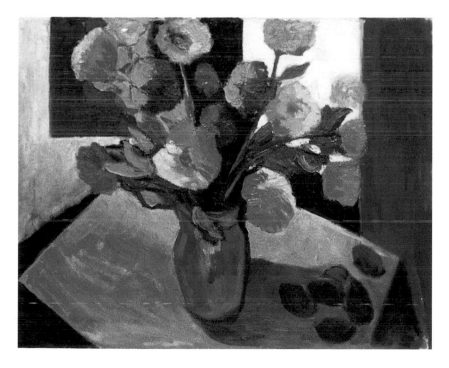

Seated Nude No. 2
1994
Oil on linen
24 x 20 in.
Collection of Patti Imhof

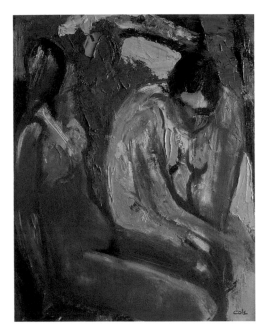

In the Garden
1993
Oil on paper
20 x 16 in.
Collection of Charles F. Vulliet

influenced initially by the French Impressionists, then later by the German Expressionist painters. There's also a hint of Arthur Dove in the intense colors of Cole's landscapes. But he claims as his most enduring influence the paintings of the Canadian Group of Seven, whose work he came upon during a visit to an art gallery in Vancouver, B.C.

Like Lawren Harris, probably the best known of that group, Cole resolves the forms of landscape into manicured color-field cutouts. But Harris's streamlined works seem confectionery beside the rough power of Cole's surfaces. Of all of the members of the Group of Seven, Cole was most smitten with the work of Tom Thomson, who worked as a commercial artist in Seattle from 1901 to 1905, before he became part of the famous Canadian group. Thomson captured the feeling of landscapes with electrically intense colors and dynamic rhythmic patterns—characteristics that are visible in Cole's work as well.

"Thomson doubtless would have become better known had he not died at age thirty-seven," Cole says. "I can only imagine what he might have become. You don't mature as a painter until you're fifty."

Cole also speaks of another important influence in his life as an artist. "Van Gogh was everyone's idol. His importance to me was his stumbly drawing ability. I have a clumsy drawing ability that I have developed into something deliberate. I found that I like to draw that way. There's a bit of naïveté in my work, and I want to keep it there."

The painter and teacher Tom Sherwood once observed, "Often Cole's handling of paint suggests that he has taken up the largest possible brush or knife to attempt some smallest touch of color. I think we owe the peculiar freshness of Cole's work, at least in part, to this craft of clumsiness. It gives us the sense of the painter's complicity with something happening alongside him over which he does not have moment-to-moment control, but for which he must take full responsibility, both to preserve what happens and, if possible, to enhance it."[2]

Cole works outdoors whenever possible, sometimes combining painting with a fly-fishing excursion. "Confronting the natural scene is the most important thing to a landscape painter," he said. "I sometimes go back to a scene three or four times." He once told an interviewer, "In order to paint a stream one must first stand in it, feel the force of it, smell it. Much of my process entails being cold at night, lighting a campfire to stay warm, waking to a sunrise and scrambling to get the paints out and put something down on canvas before it is lost. Some might say that this is too complicated. All that stuff outdoors seems too hard to handle. But then, is there any other way? Perhaps so, but not for me."[3]

Studio work—time in which he can reflect on what he has painted, study his sketches, and finish and refine what he began outdoors—is also invaluable. Still life studies and figurative paintings are a critical part of his output. "Every couple of John Cole exhibitions, we have a small group of

his figurative and still life pieces," says Lisa Harris, whose Seattle gallery has shown his work for fifteen years. "They're a terribly important part of what he does, because it's part of his limbering up; preparation for his work outdoors."[4]

She speaks of Cole's Genesis series as a continuing search for the archetypal Northwest landscape. "He had the trees and the water, and the missing element was the figure." Two paintings from the Genesis series are in the exhibition. In the foreground of *The Dance (By the Waterfall)* painted in 1995 (page 81), two figures join their outstretched arms in a circling dance reminiscent of Matisse's *La Danse*. It was a preliminary study for *Genesis No. 5* (page 80) also from 1995, in which nude figures, each oblivious to the presence of the others, make their way past the trunks of dark trees, backlit by the reflected light thrown from a waterfall.

Cole experiences a strong interaction between his landscapes and figure studies. "Working outdoors to create a landscape is the same as using a model for figure drawing," he explained. "In both cases you are inspired by the real thing. The work takes on a freshness and vitality. It's not a matter of simply reproducing the scene, but rather selecting and observing visually, and feeling. Nature always seems to reveal something more than one's imagination expects."[5] Cole does not often work from photographs, except occasionally to remind himself of some detail of a scene he has sketched. "Photos are static," he says. "They never get the edges of a scene."

For the most part, Cole puts in a steady thirty to forty hours a week and has evolved a working method that yields the result he seeks. Before he begins a painting, he prepares the canvas with a pink glaze mixed from cadmium orange and dioxazine purple "to get rid of the whiteness of the canvas right away." In his finished paintings, bits of that pink background are sometimes visible through voids in the trees.

After he has determined what part of his surroundings will appear in the painting, he draws directly on the canvas, often with black paint. A staccato black line outlines trees and mountains. But it is no ordinary black straight from the tube. Admixtures of purple, and viridian green, and alizarin crimson make it more lively to the eye, which discerns flecks of the green and red, even when the viewer is not conscious of it.

"Black holds a painting together when I mix it with different hues for various parts of a scene," he says. The green of a tree may be a mix of cadmium yellow and black, while a rosy streak of sky is a mix of black and cadmium orange. His finished paintings combine the tension of gesture in the black strokes with the vibration of color fields

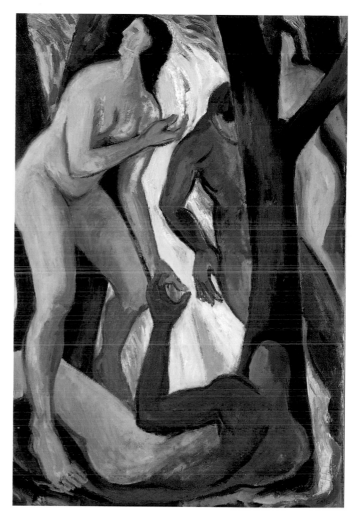

Genesis No. 4
1994
Oil on board
48 x 32 in.
Collection of Charlene Kase

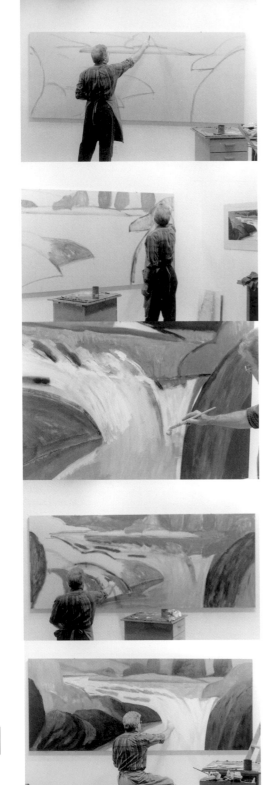

in the shapes of trees, which are as clean-edged as if they had been scissored and collaged into place.

The merest glance at one of his canvases makes clear that he is first and foremost a colorist. He handles color like a sorcerer. He studies a canvas still on his easel that has a green sky, blue water, and surrounding fields of a complementary yellow: "It couldn't be any color but green," he says of the sky, as if there were no choice in the matter.

Other equally brilliant elements are nature's work, a result of changing light during the course of a day. Although he exercises considerable care in the selection of a scene, and the way it is laid out on the canvas, he says, "Good painting is often brought about by accidents." To illustrate, he points to a canvas in which a streak of late sunlight stabs across a background field like a dagger that holds everything else together. "I have to start a painting by ten or eleven o'clock in the morning to be far enough along with it in preparation for the time when the raking shadows come along to make it a really interesting composition."

Sherwood, himself a careful student of color, says, "Those unctuous passages of water and sky that seem forever wet are made up of flake white, sometimes with zinc. Brilliant metallics make up the core of his palette: cadmium red and yellow against cobalt blue. Among the complements are cadmium orange and the opaque form of chromium oxide green, as well as a cobalt green. And against this brilliance is another palette where alizarin crimson and viridian (a transparent form of chromium oxide) are the ruling warm and cool colors at a lower, less vibrant, saturation. The darker edge of this palette is ultramarine blue; the lighter is a wan lemon yellow."

One additional element that often is not readily obvious adds interest to Cole's canvases: he does not conform to classical laws of perspective—one more reason the scene he paints does not look exactly as it does in nature. The paintings take shape on three tiers. "I dump it down," he explains, "then there's a shelf, then I dump it down again, like a stepladder." The technique is perhaps most readily visible in *Little Falls No. 3* (page 72), painted in 2000, although close attention to nearly any of his canvases will yield evidence of the practice.

Cole's work has gained slow but steady momentum in the art world. He was nearly fifty before he began to have regular solo gallery exhibitions, first at the Blue Horse Gallery in Bellingham, then at the Lisa Harris Gallery in Seattle, which this year hosts its tenth. His last few shows have achieved that ultimate dream: they have sold out. Quietly, without entering the fray of art politics, Cole has become one of the major names of Northwest art.

In this retrospective exhibition, covering more than thirty years, from a 1969 canvas, *Along the Cedar River*, to a number of paintings completed in 2002, we are privy not only to the range of Cole's painterly powers, but to the course of their development as his style matured and strengthened.

The spun-sugar texture of the green bubbles of trees in *Along the Cedar River* contrast sharply with the solid red bones of *Madronas* (page 52) done in 2002. In the years between those paintings, the painter has become more bold; his hand has become more sure; his eye more acute. Each painting features half a dozen trees, but the difference could scarcely be more remarkable. The trees are generic in the earlier painting; pretty in an impressionist way. We do not know exactly what kind of trees they are; it scarcely matters. In *Madronas* the trees there is no mistaking their genus—are so strong they jump out into the viewer's space. Four of them, with peeling bark, lean out of the foreground, as abandoned as party animals on a waterfront outing. Their bases are lost outside the edges, or obscured by translucent golden undergrowth. The red trunks swell thick and rich against the yellow ground, the sky-blue water, a range of purple mountains, and the unexpectedly lemon sky. The dark branches of a leafless shrub spring from below the bottom edge, and two more trees, neatly conical young evergreens, stand behind to the side of the main show, hard-edged as pieces of a picture puzzle.

Look carefully at the canvases in this retrospective exhibition, because reproductions of Cole's paintings flatten out a crucial aspect of the character of the paintings themselves. When confronting a Cole painting directly, one becomes aware that the real subject is not the scene, but paint on canvas, and the rich play of brushstrokes that record his process. This painterly brushwork is difficult to capture in photographs. The closer

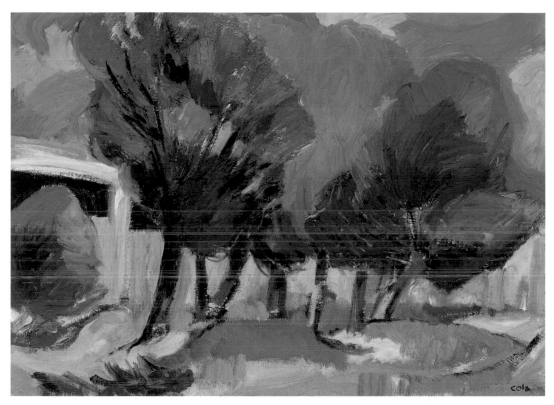

one moves to Cole's paintings, the more power can be seen to emerge from them. These are paintings that meet you more than half way. They jump at you; they clap and sing.

The careful viewer will also notice some differences in paintings from differing locales. The exhibition focuses on landscapes from seven areas: Alaska; Vancouver Island and Chilcotin in British Columbia; the Deschutes River and the Umpqua River, both in Oregon; the Okanogan in Eastern Washington; and the area around Bellingham, which encompasses Whatcom and Skagit Counties.

Along the Cedar River
1969
Oil on canvas
18 x 24 in.
Collection of Lucille Cole

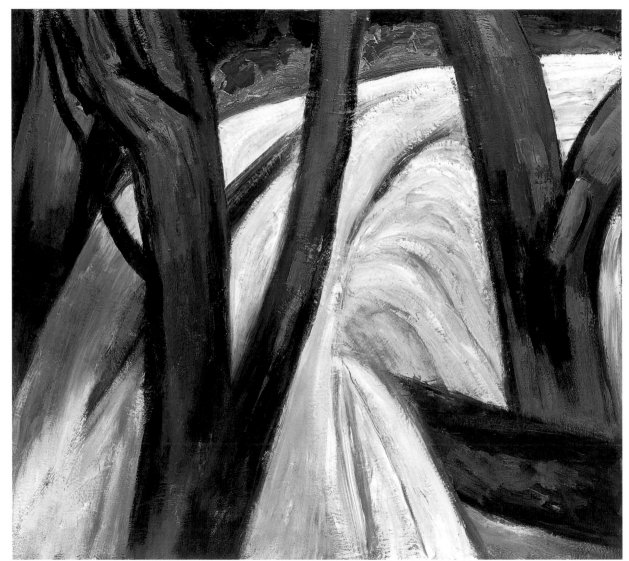

The Source
1992
Oil on linen
36 x 40 in.
Collection of Charles F. Vulliet

The Alaskan paintings all date from 1997. They display the most restricted palette of any of Cole's works, and the highest drama: black, white, and shades of blue that range through deep purple. *Alaska Night* (page 24) shows the twilight darkness of an Alaskan summer night that, at midsummer, is still light enough for outdoor games at midnight. One painting from the series shows a glacier cutting a narrow sluice between dark mountains, and meeting the water's edge in the glossy light reflected from ice.

The flow of energy in his compositions is palpable. "I am never sure what it is about an arrangement of objects or a selected scene that evokes the need to record my feelings until the work begins," Cole has written.[6] But even he may not know the full reasons behind his choice of places and the colors in which they appear in paint.

If it is true that every painter reveals himself in his work, then we may assume that the glowing shadows and celebratory colors of Cole's landscapes reveal rather a different aspect of his character than the quiet diffidence he presents to the world in conversation. The paintings are like landscapes burnt bright in memory. He is locking in a vivid appreciation of each place and each day, and inviting us to do the same.

NOTES

1. Quotations from John Cole not attributed otherwise are from the author's conversations with him in February 2003.
2. Tom Sherwood, "A Further Notice of John Cole's Paintings," unpublished manuscript.
3. Interview with John Cole by Tonie and Wade Marlow, *Art Waves*, Winter 1988, unpaginated.
4. Conversation with the author, 19 February 2003.
5. Marlow interview.
6. Undated, unpublished artist's statement.

Alaska

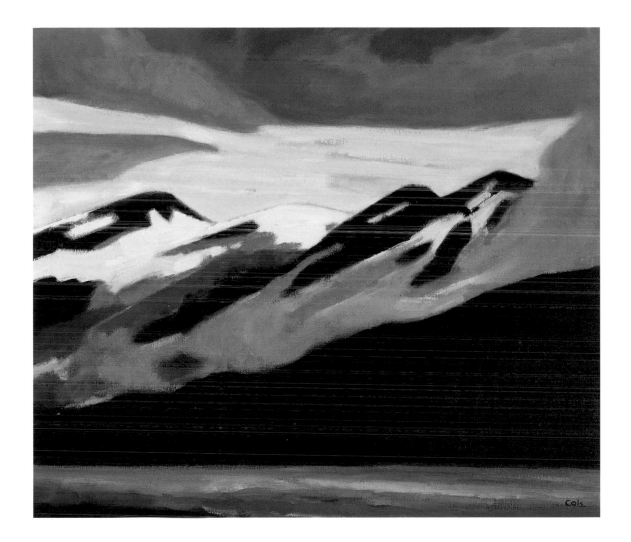

Alaska No. 6 (Scene from Glacier Bay)
1997
Oil on linen
24 x 28 in.
Collection of Lucille Cole

23

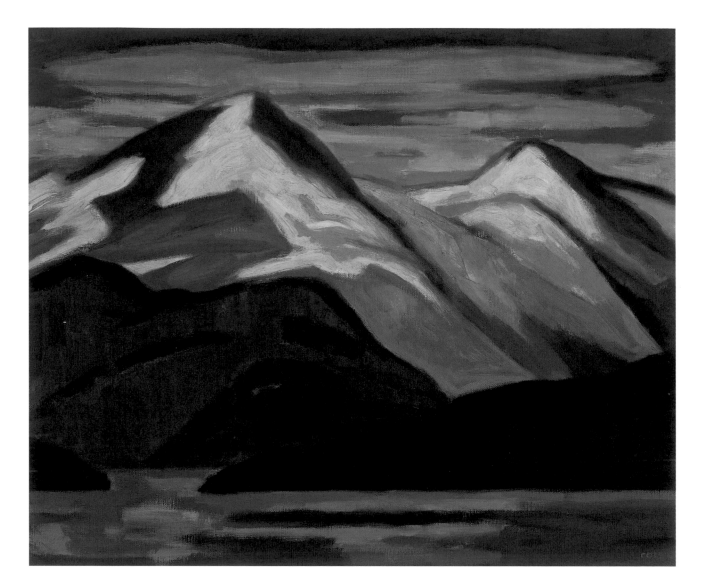

Alaska Night
1997
Oil on linen
30 x 36 in.
Private collection

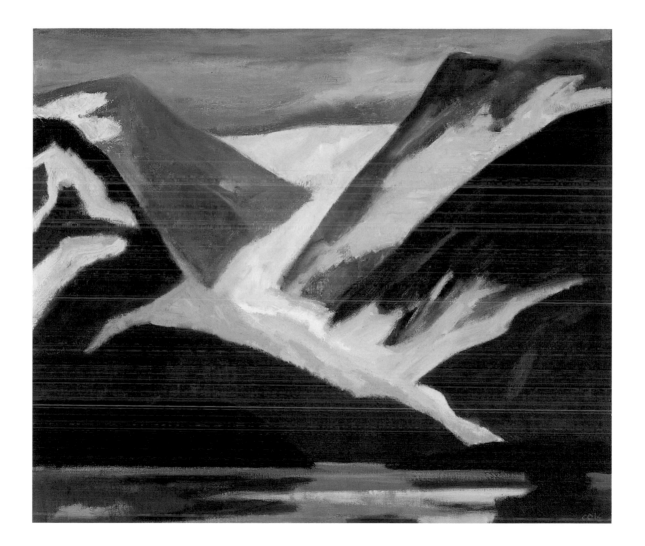

Glacier
1997
Oil on linen
24 x 28 in.
Collection of Heidi and
Mark Craemer

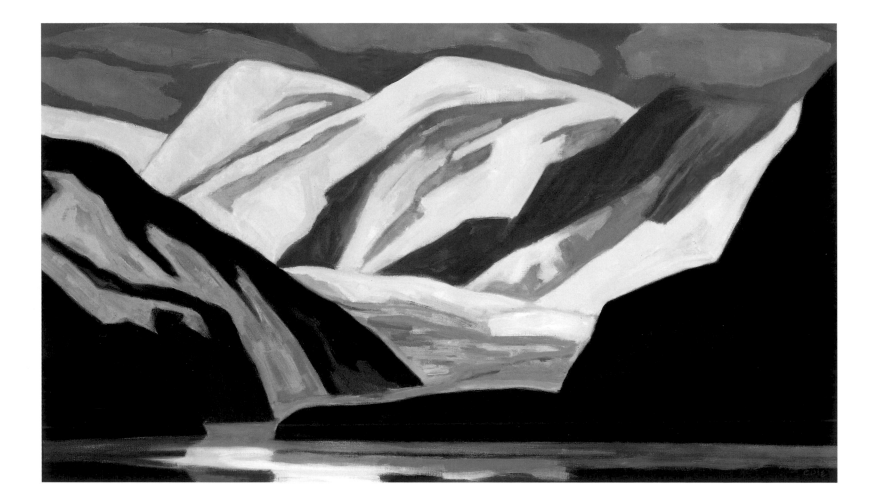

Glacier Bay
1997
Oil on linen
28 x 48 in.
Collection of Bard and
Julie Richmond

Chilcotin

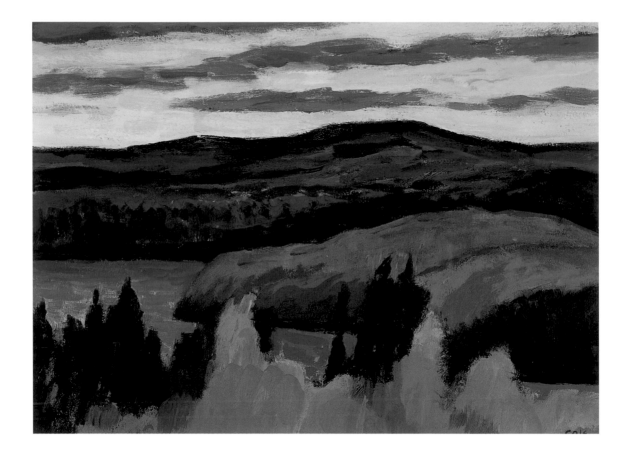

Morice River
1986
Acrylic on paper
14 x 19 in.
Collection of Lucille Cole

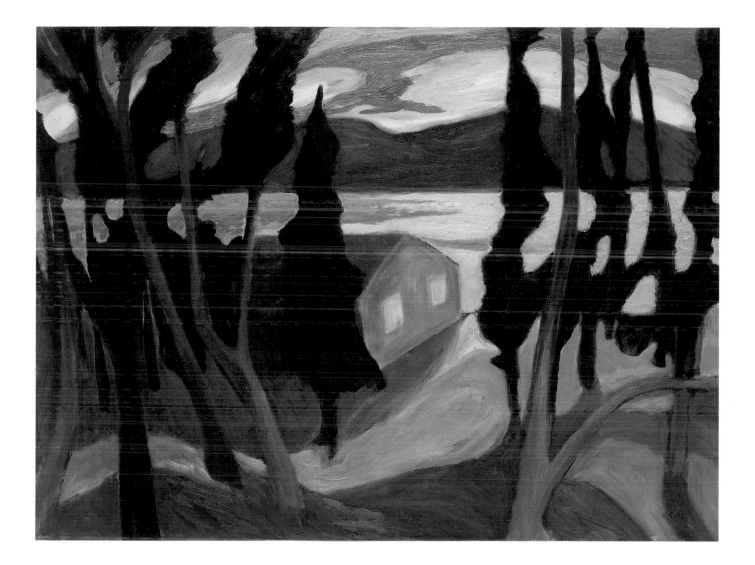

Cabin at the Lake
1989
Oil on linen
36 x 48 in.
Private collection

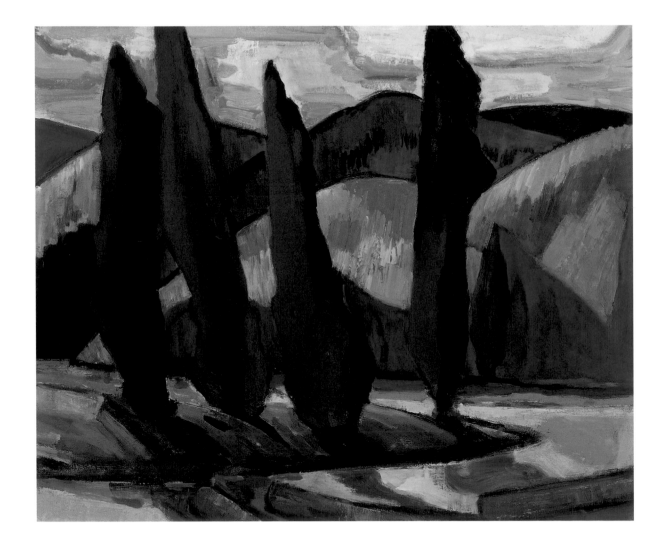

Red Trees
1994
Oil on linen
30 x 36 in.
Collection of Lynne Wandrey

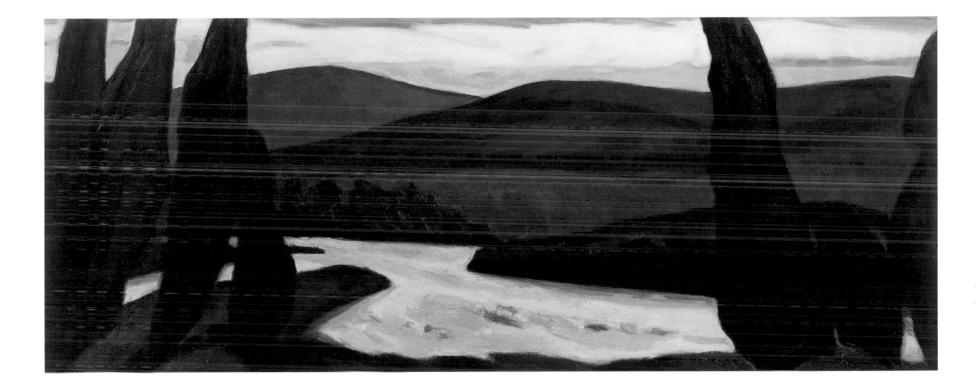

Chilko
1998
Oil on linen
36 x 90 in.
Collection of Nancy Packard and
Gary Rosen

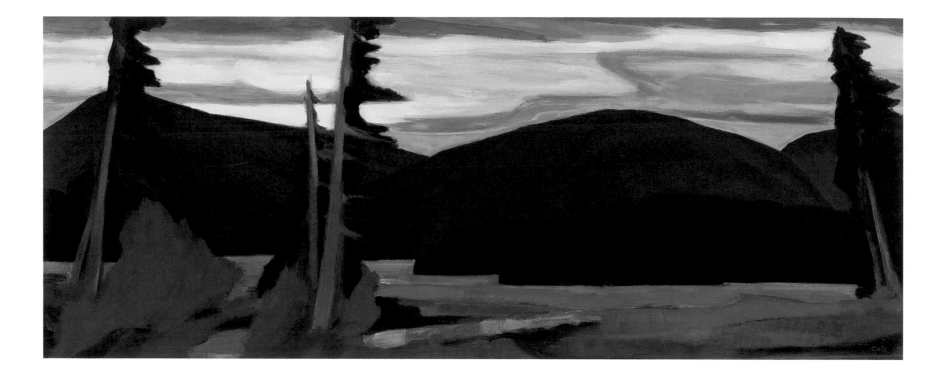

Tatler Lake
1998
Oil on linen
28 x 70 in.
Collection of Millie Livingston

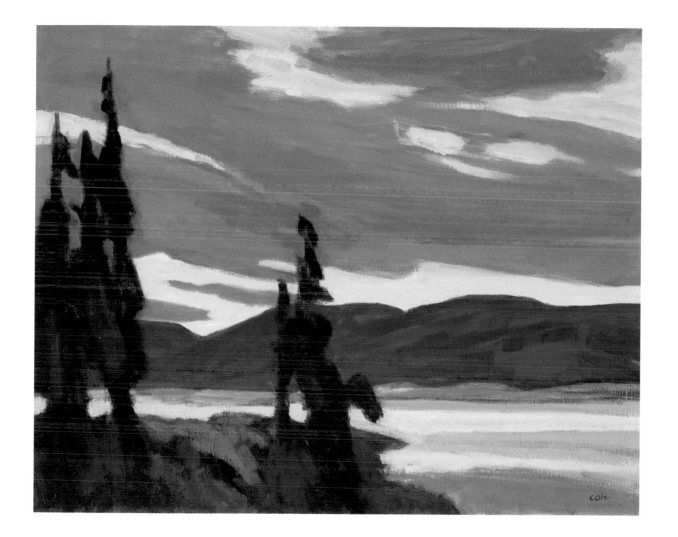

Eagle Lake
2000
Oil on linen
24 x 30 in.
Collection of Jill and
Edward Rosenthal

Deschutes River

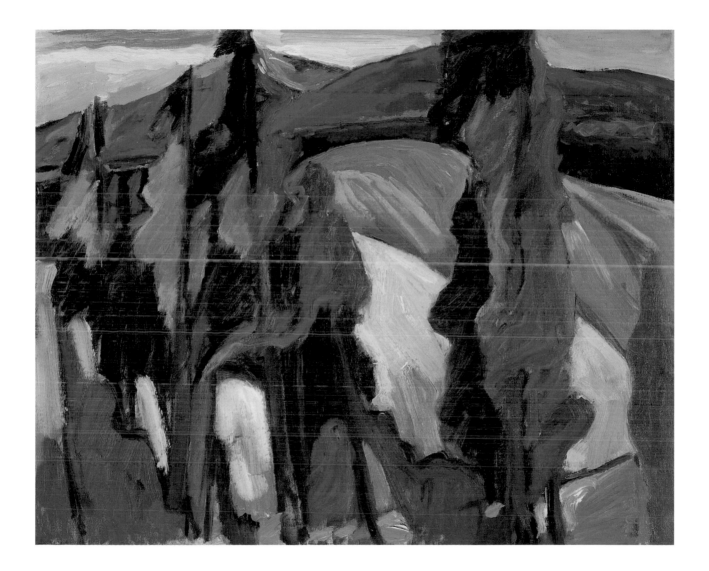

Metholius River
1985
Oil on linen
24 x 30 in.
Collection of Brett & Daugert Law Firm

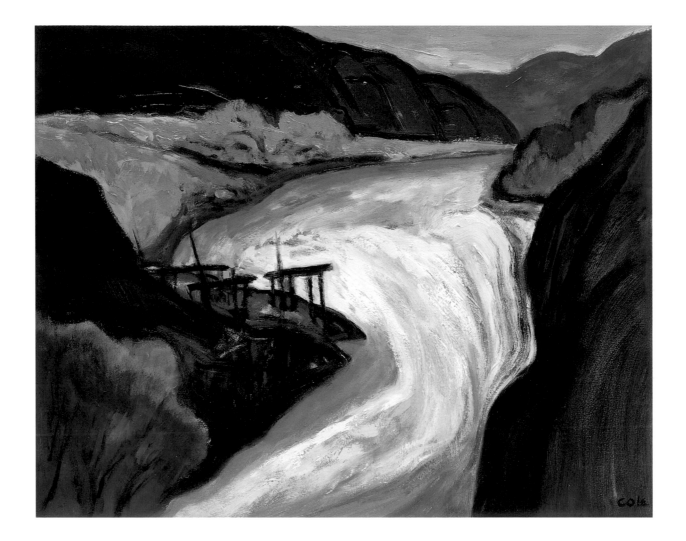

Sherars Falls
1991
Oil on paper
16 x 20 in.
Collection of Anita Baker

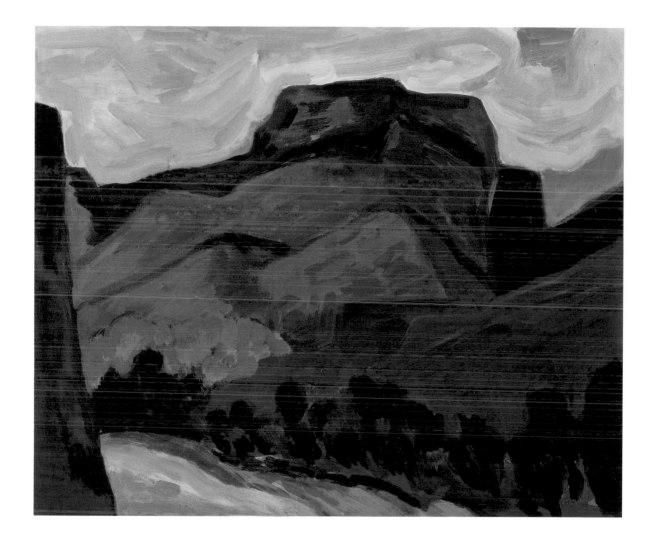

Whitehorse Canyon
1991
Acrylic on paper
20 x 24 in.
Private collection

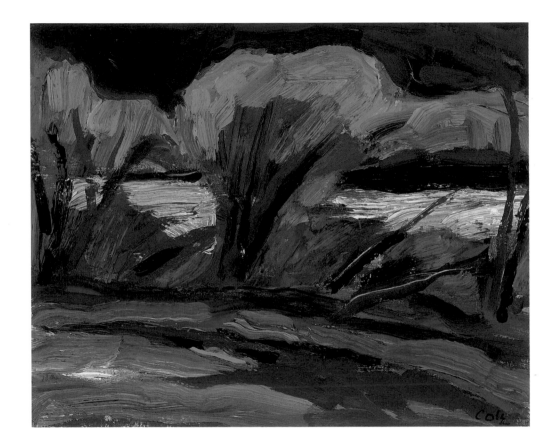

Autumn Gold
1992
Oil on paper
8 x 10 in.
Collection of Theresa Slechta

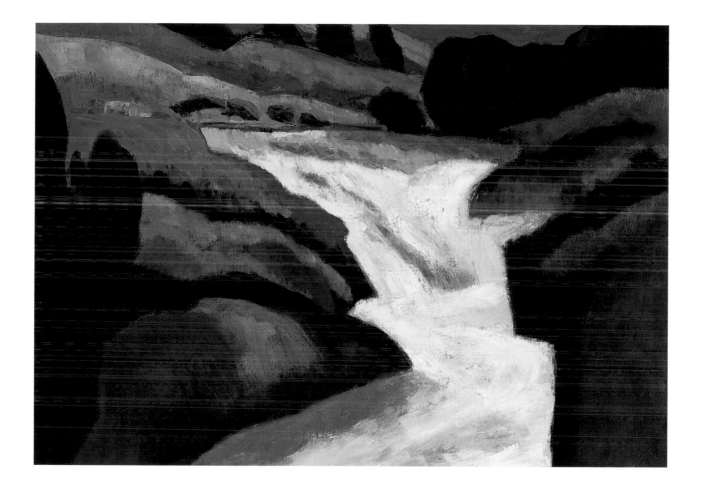

Waterfall
1997
Oil on linen
24 x 34 in.
Collection of Cathy Gilbert

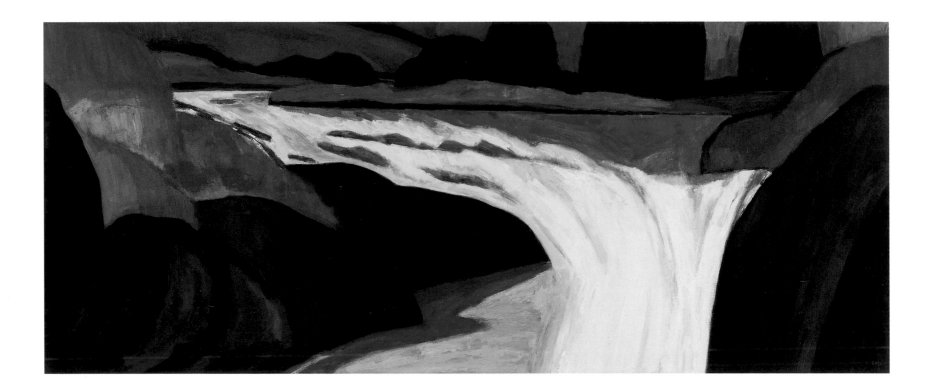

Sherars Falls
1999
Oil on linen
50 x 120 in.
Collection of Brad Lovering and
Valarie Baker

Western Washington

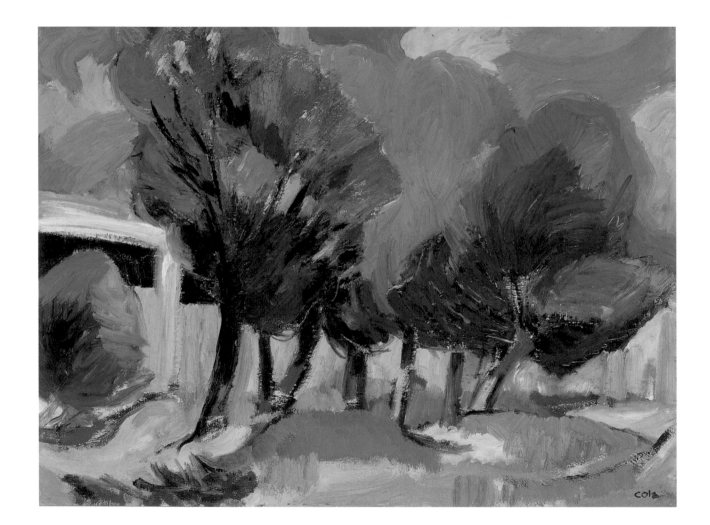

Along the Cedar River
1969
Oil on canvas
18 x 24 in.
Collection of Lucille Cole

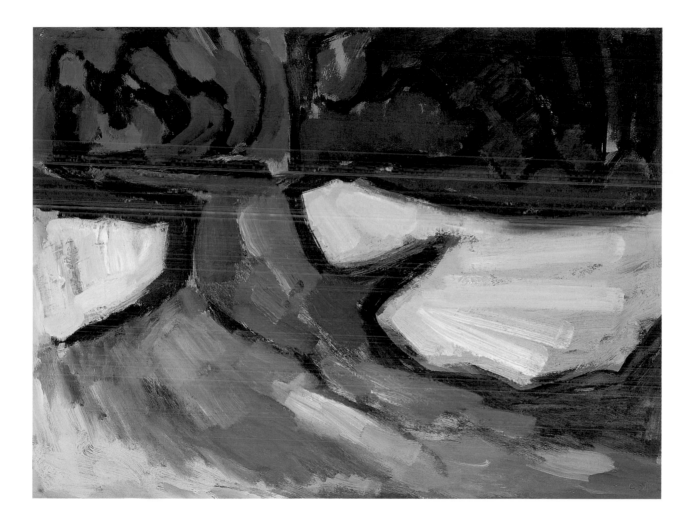

Toutle River Landscape
1980
Oil on paper on board
18 x 24 in.
Collection of Thomas Wood

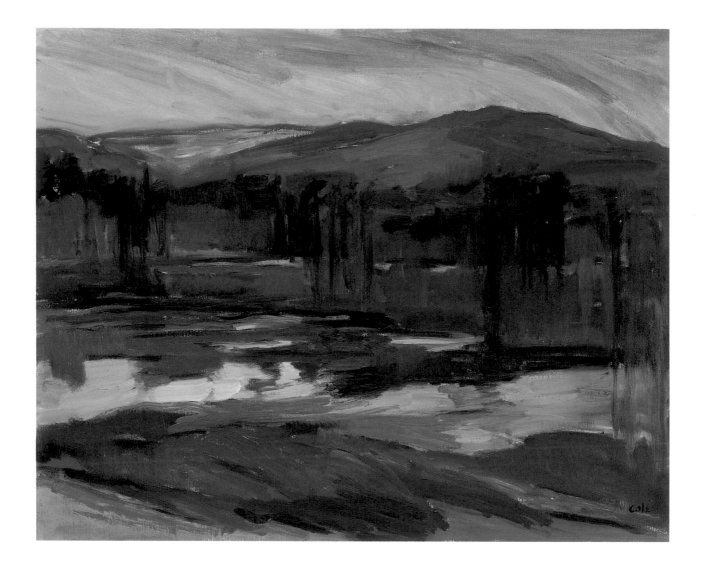

Hovander Lake Sunset
1987
Oil on linen
24 x 30 in.
Collection of Dorothy and
Tom Sherwood

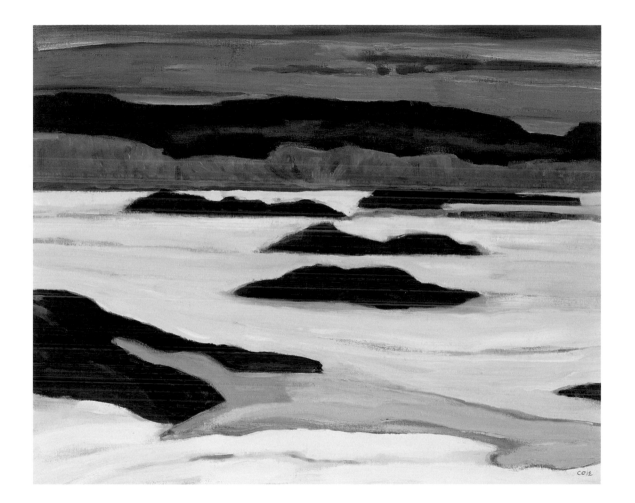

Terrell Lake Winter
1987
Oil on linen
18 x 24 in.
Collection of Dorothy and
Tom Sherwood

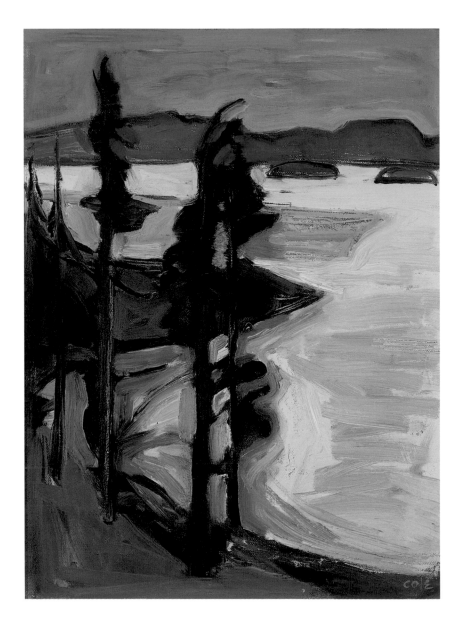

View from Chuckanut
1989
Oil on paper on board
16 x 12 in.
Collection of John Sisko

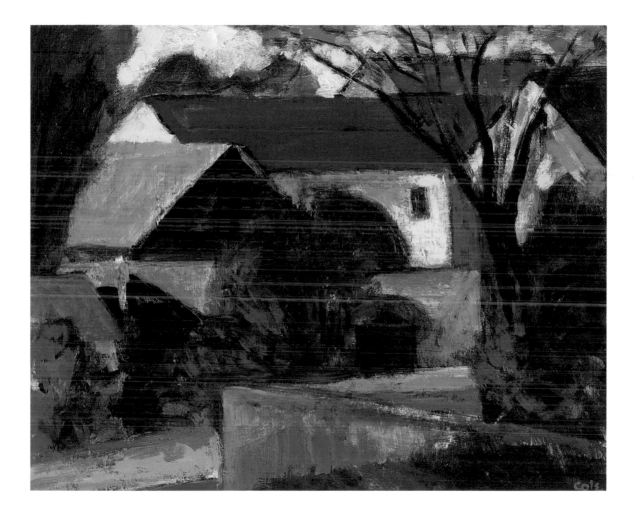

Illinois Street
1991
Oil on paper
16 x 20 in.
Collection of Marie Doyle and
Robert Ingman

47

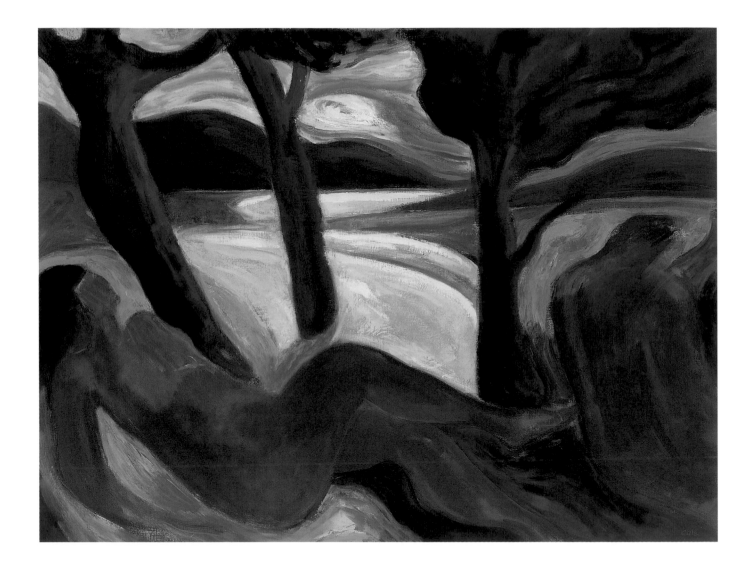

Northwest Evening
1991
Oil on linen
36 x 48 in.
Collection of Linn Gould and
Timothy Summers

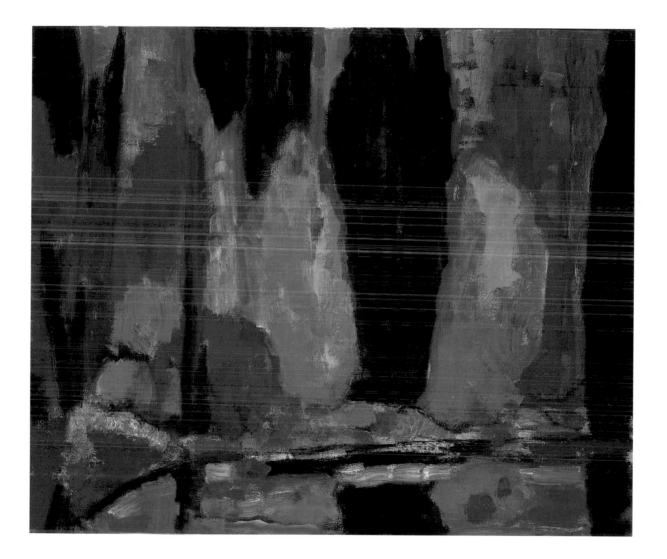

Autumn
1997
Oil on linen
30 x 36 in.
Collection of Larry Holder

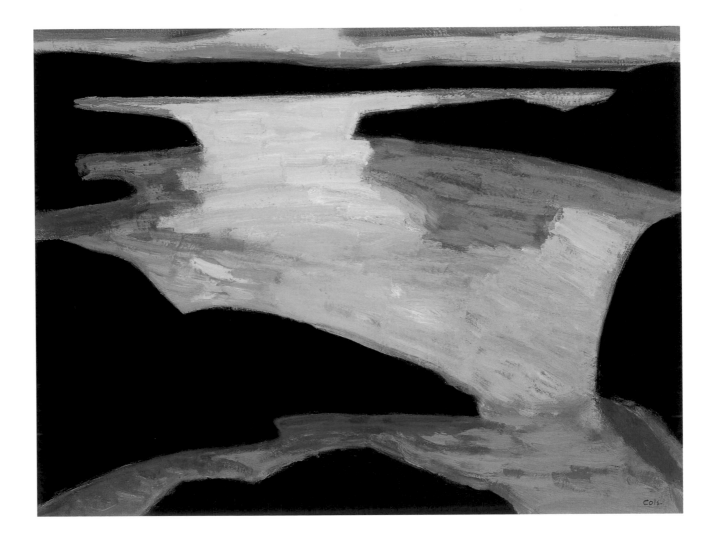

Bay of Mystery
1997
Oil on linen
36 x 48 in.
Collection of David Groff and
Roslyn Solomon

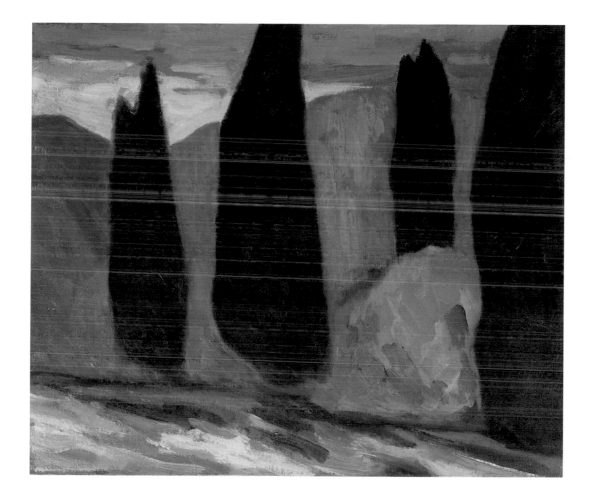

Along the Nooksack
1998
Oil on linen
20 x 24 in.
Collection of Brad Lovering and
Valarie Baker

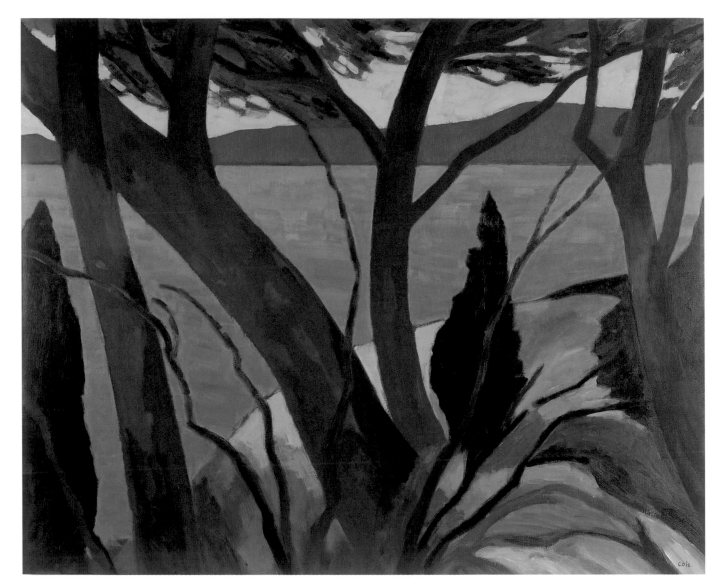

Madronas
2002
Oil on linen
48 x 60 in.
Collection of Millie Livingston

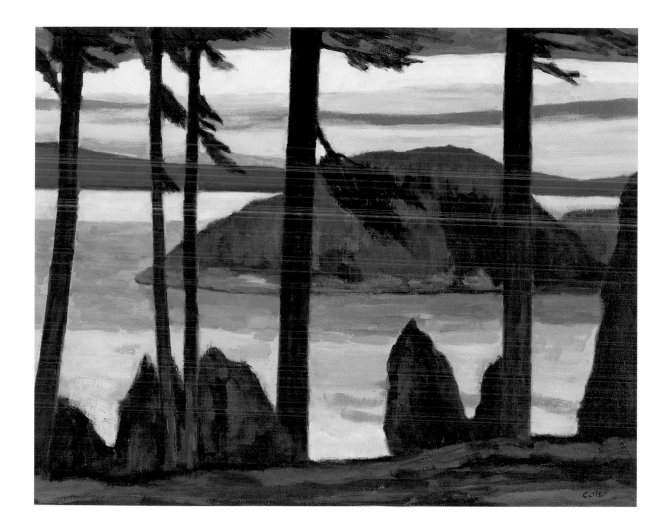

Clark's Point
2001
Oil on linen
22 x 28 in.
Collection of Mary and Albert
Froderberg

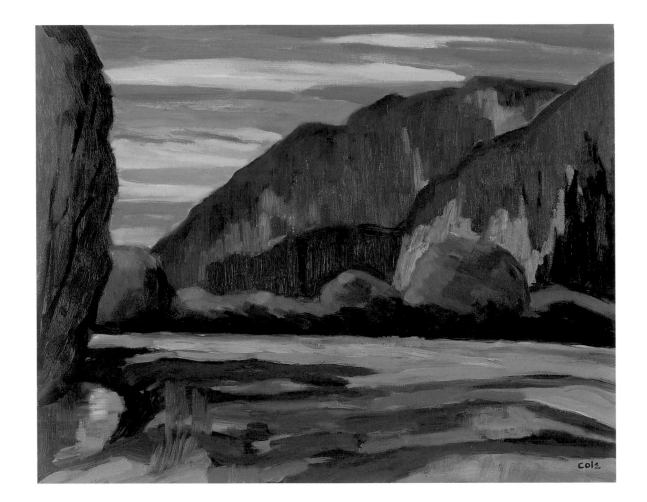

Evening Light
2001
Oil on linen
16 x 20 in.
Collection of Tom and
Tamsyn Marie Palmesano

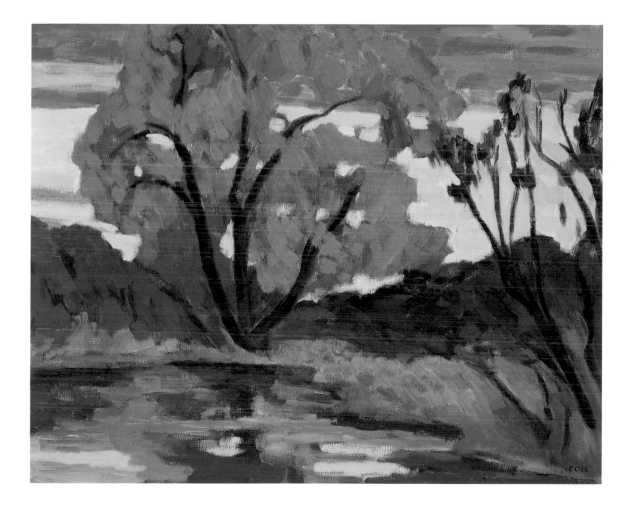

By the Pond
2001
Oil on linen
16 x 20 in.
Collection of Brad Lovering and
Valarie Baker

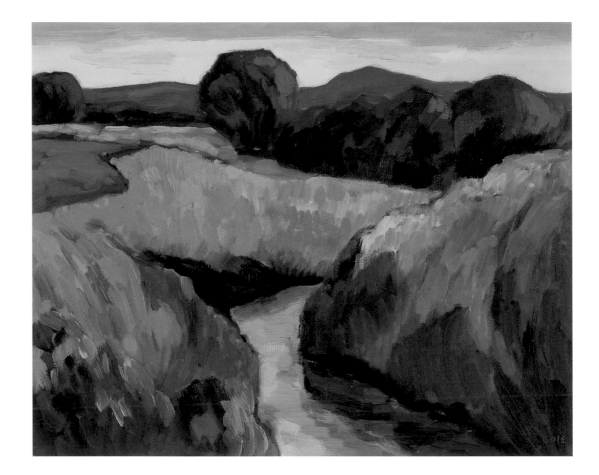

Skagit Valley Scene
2001
Oil on linen
16 x 20 in.
Collection of Dorsey & Whitney LLP

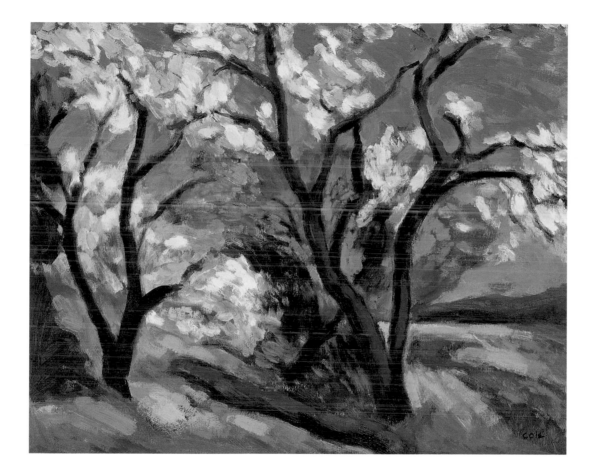

Wild Fruit Trees
2001
Oil on board
16 x 20 in.
Collection of Stephen Nute

Okanogan

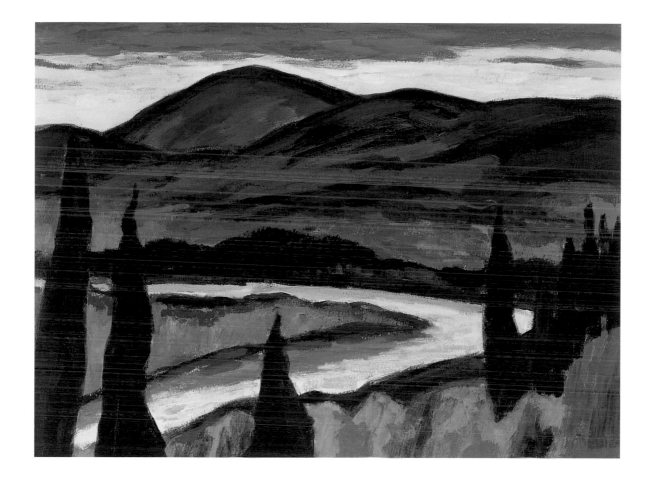

Bend in the River
1985
Acrylic on paper
14 x 19 in.
Collection of Stephen Nute

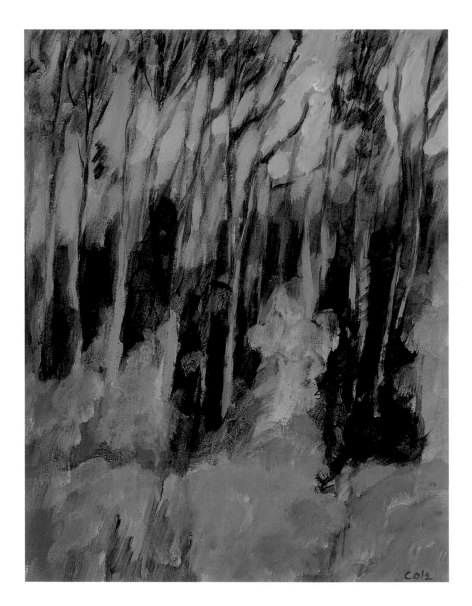

Trees at Gusterson Lake
1985
Acrylic on paper
19 x 14 in.
Collection of Lucille Cole

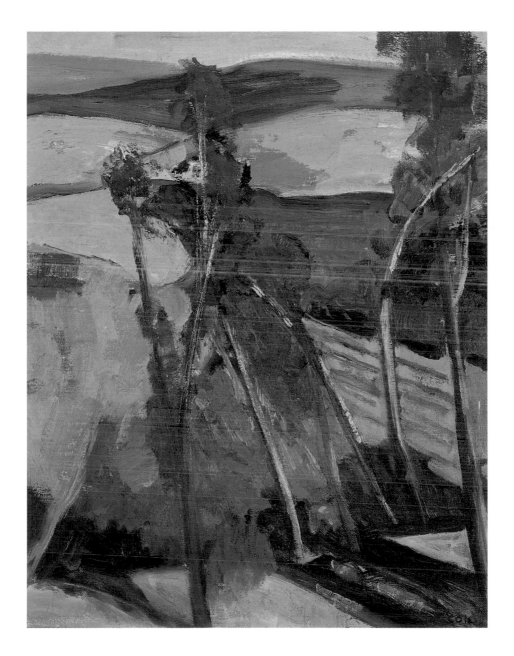

Trees on Biscuit Ridge,
Walla Walla
1990
Oil on linen
20 x 16 in.
Collection of John Sisko

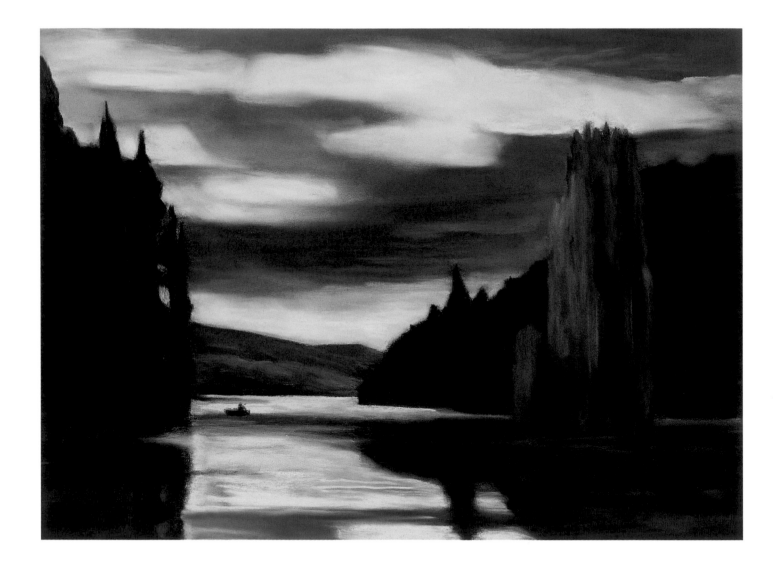

Mysterious Lake
1995
Pastel on paper
20 x 28 ½ in.
Collection of Charles and Susan
Pearson

Umpqua River

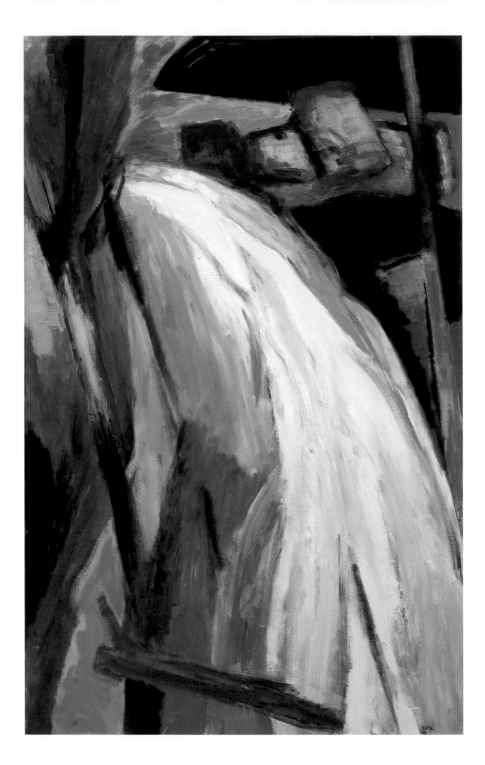

Waterfall No. 8
1992
Oil on linen
80 x 50 in.
Collection of Al and Lisa
Van Kampen

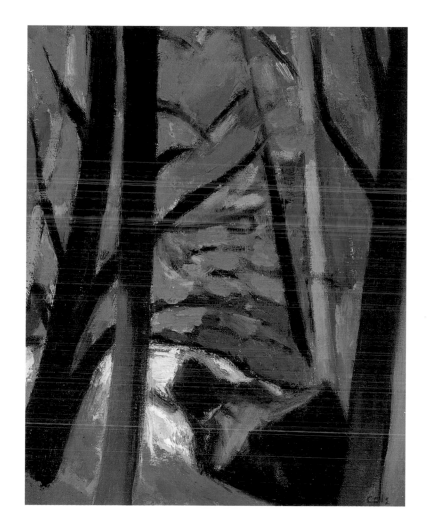

Fall—Umpqua River
1995
Oil on linen
16 x 13 in.
Collection of Dr. and Mrs.
Bruce Blasberg

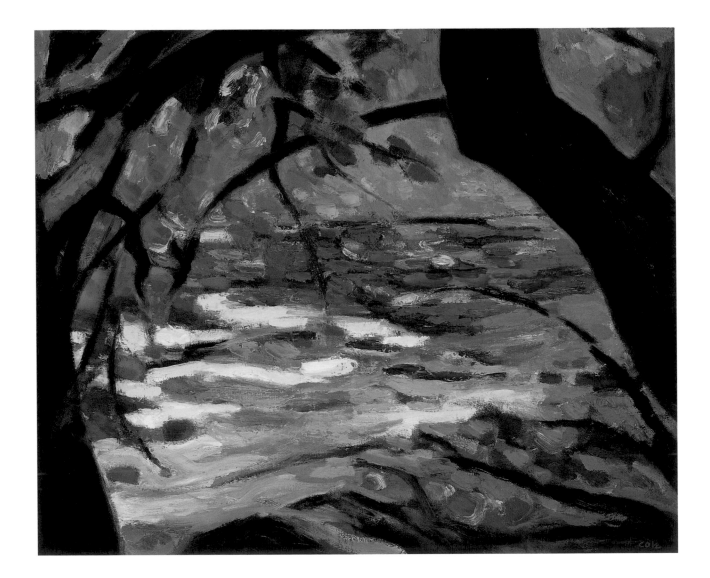

Fall, Umpqua River
1997
Oil on linen
36 x 44 in.
Collection of Eric Olanie

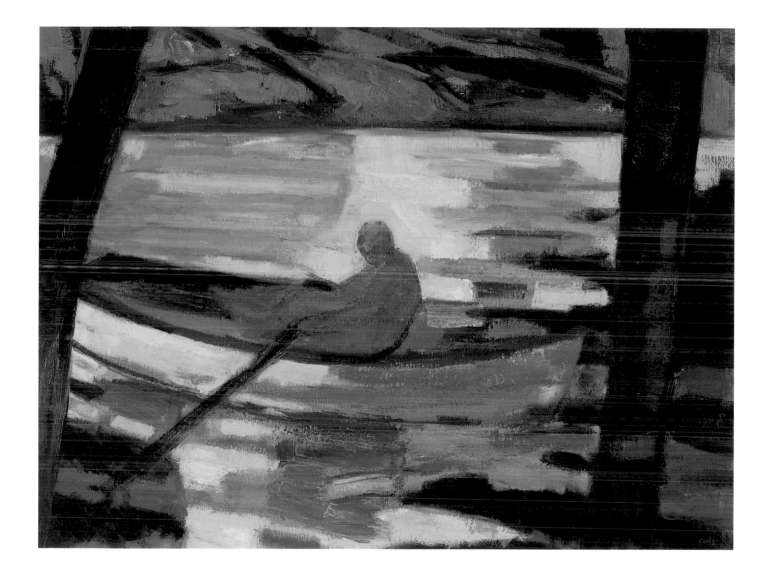

The Rower
1998
Oil on linen
36 x 48 in.
Collection of David Groff and
Roslyn Solomon

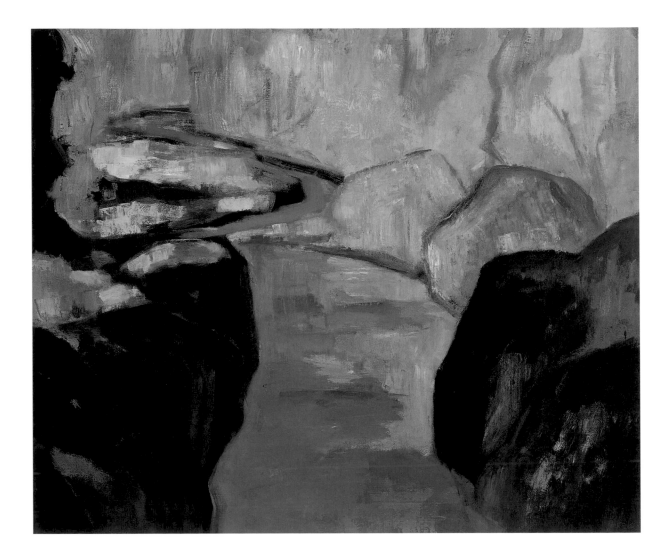

Steamboat Creek
1998
Oil on canvas
30 x 36 in.
Collection of Eric Peterson and
Barbara Pomeroy

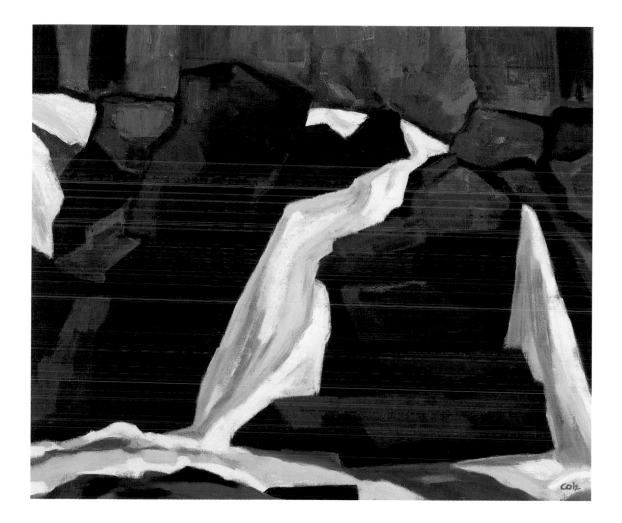

Little Falls No. 2
1998
Oil on linen
30 x 36 in.
Collection of David and
Virginia Ridgway

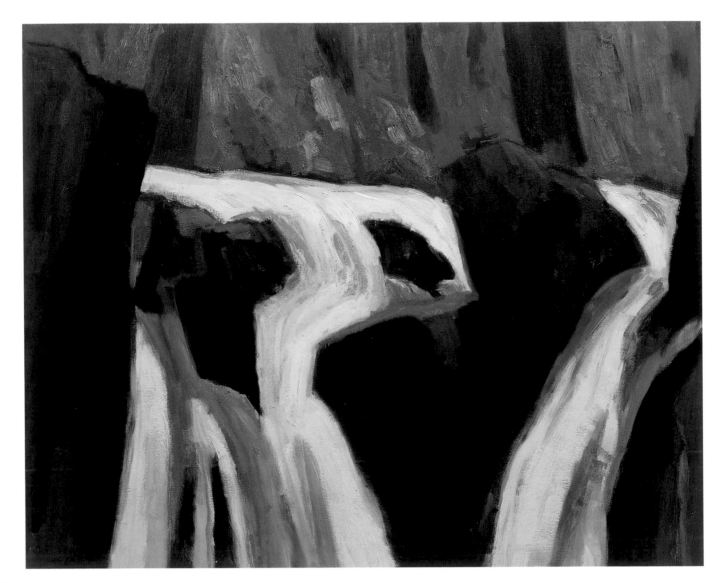

Waterfall
1998
Oil on linen
48 x 60 in.
Private collection

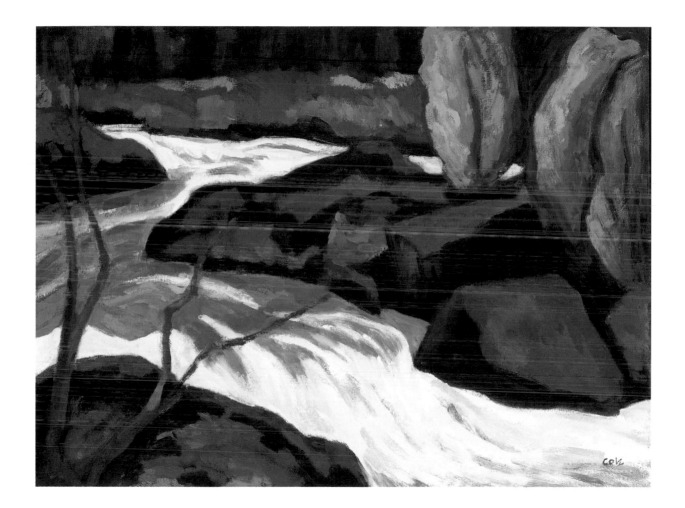

Bend in the River
2000
Oil on linen
24 x 32 in.
Collection of Brad Lovering and
Valarie Baker

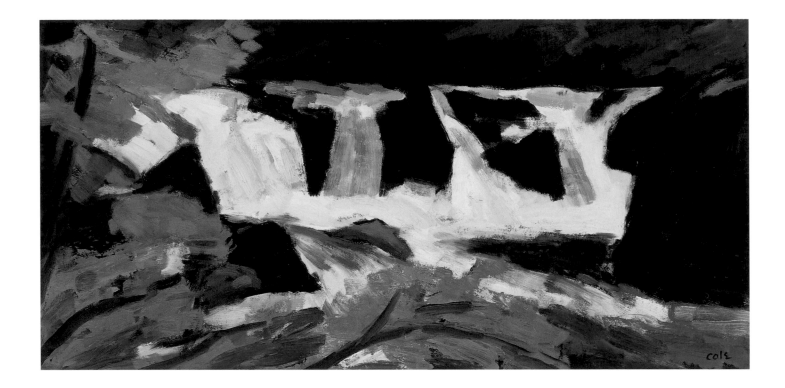

Little Falls No. 3
2000
Oil on linen
15 x 30 in.
Collection of Lisa Harris and David
Wendel

72

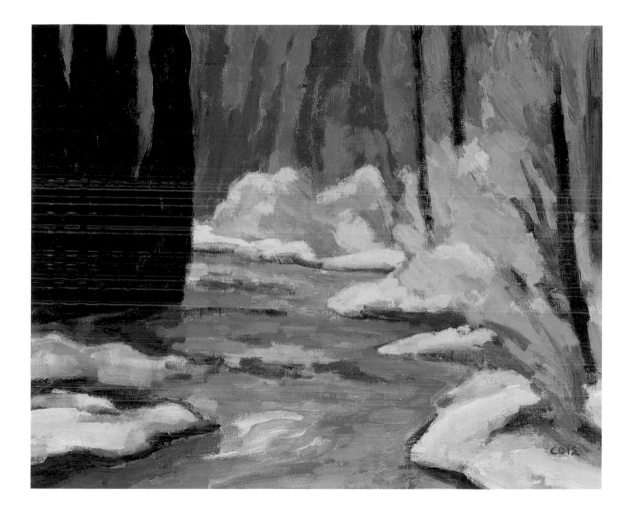

North Umpqua Creek
2000
Oil on linen
13 x 16 in.
Collection of Stephen Nute

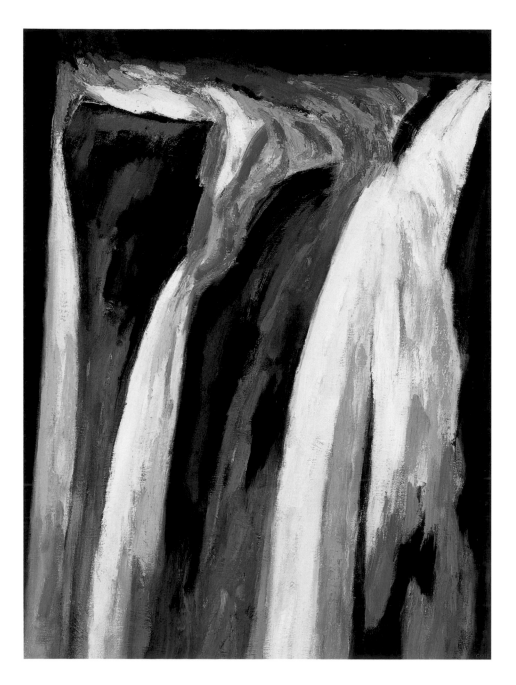

Waterfall
2002
Oil on linen
48 x 36 in.
Courtesy of the artist and
Lisa Harris Gallery

Vancouver Island

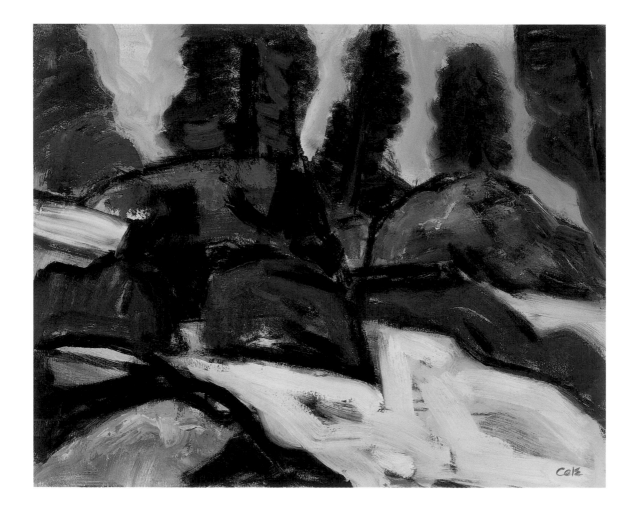

Beach Rocks
1992
Oil on paper
16 x 20 in.
Collection of James and
Karen Solimano

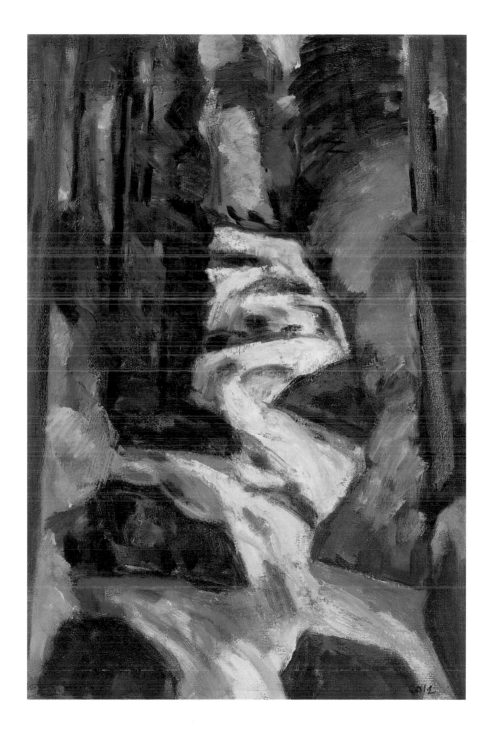

Phillips Creek
1992
Oil on paper
24 x 16 in.
Collection of the artist

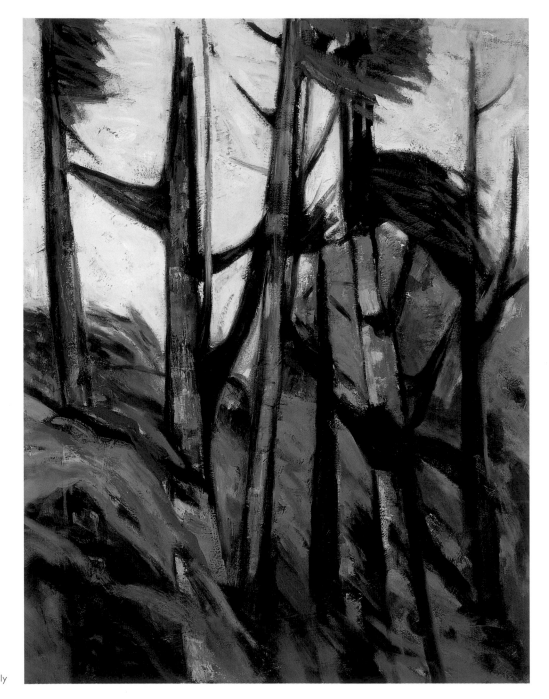

Sitka Spruce
1992
Oil on canvas
60 x 46 in.
Collection of the Behnke Family

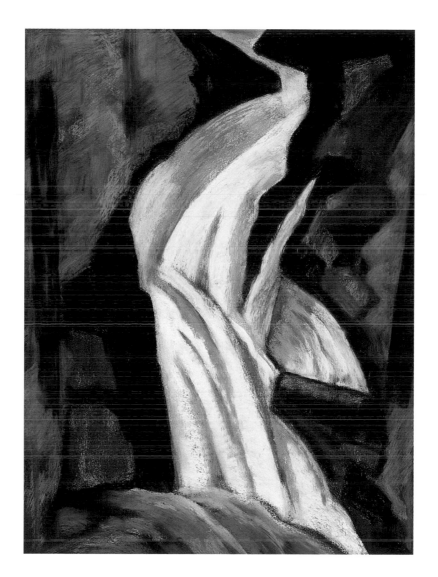

Anatomy of a Waterfall No. 2
1994
Pastel on paper
22 x 16 in.
Collection of the artist

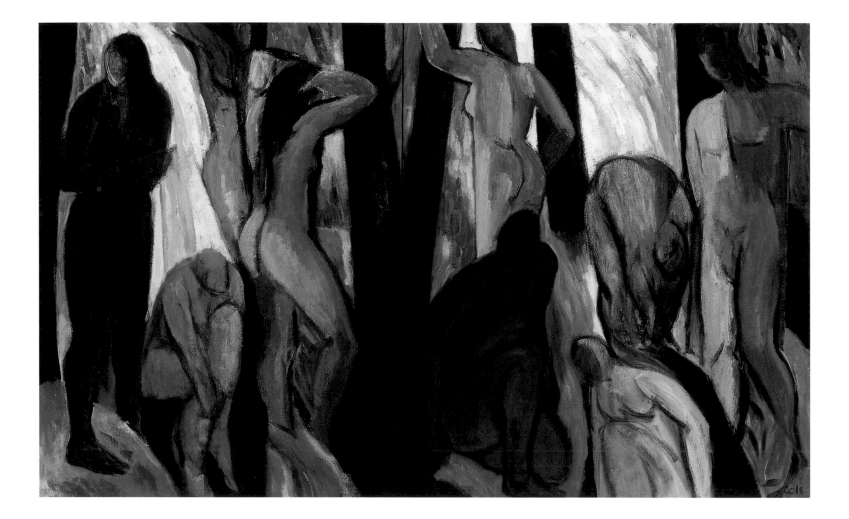

Genesis No. 5
1995
Oil on linen
42 x 68 in.
Private collection

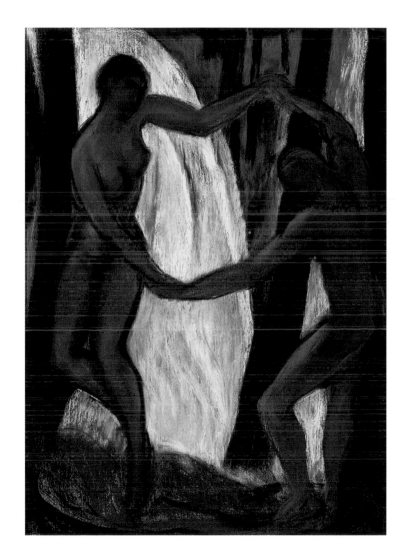

The Dance (By the Waterfall)
1995
Pastel on paper
22 x 16 in.
Courtesy of the artist and
Lisa Harris Gallery

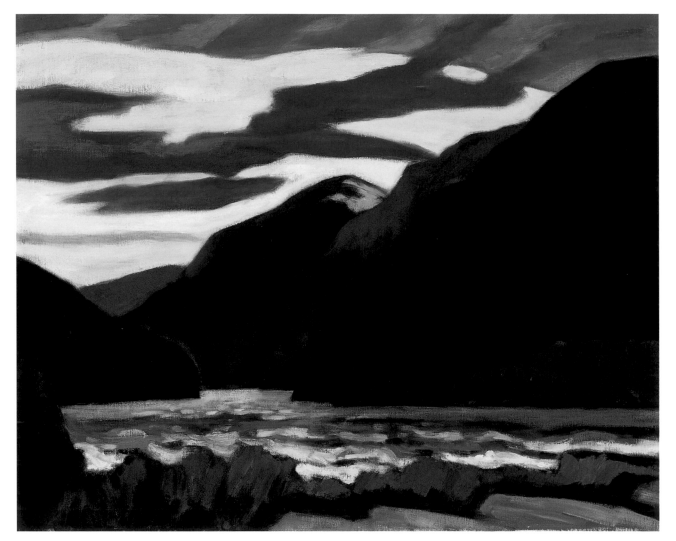

Buttle Lake
1997
Oil on linen
24 x 30 in.
Collection of Marc and
M. Leigh Barreca

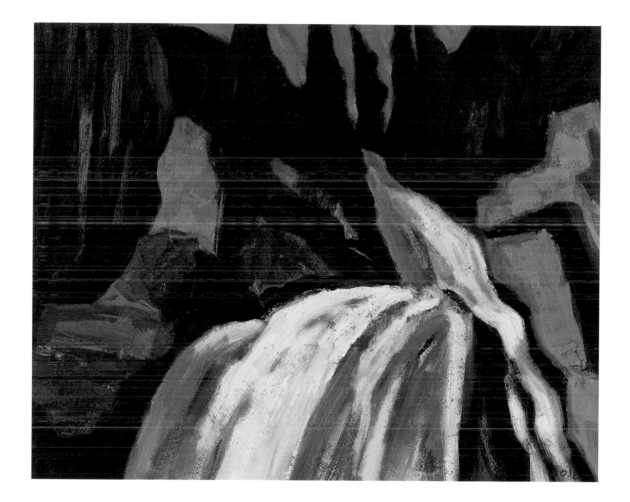

Myra Falls No. 10
1998
Oil on linen
16 x 20 in.
Collection of Michele Radosevich

Prints and Drawings

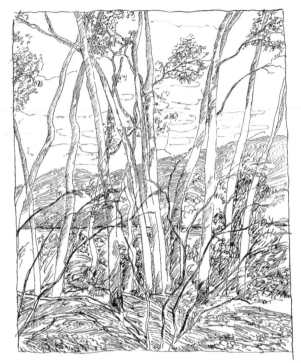

Aspens at Eagle Lake
July 1987.

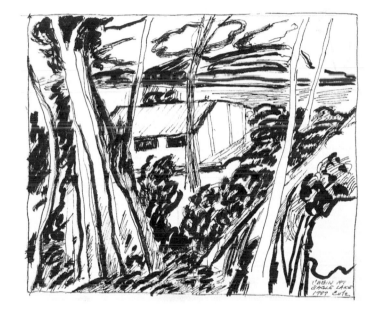

CABIN AT
EAGLE LAKE
1987 CUTZ

(left)
Aspens at Eagle Lake
1987
Pen and ink on paper
11 ½ x 8 ½ in.
Collection of the artist

Cabin at Eagle Lake
1987
Pen and ink on paper
8 x 9 in.
Collection of the artist

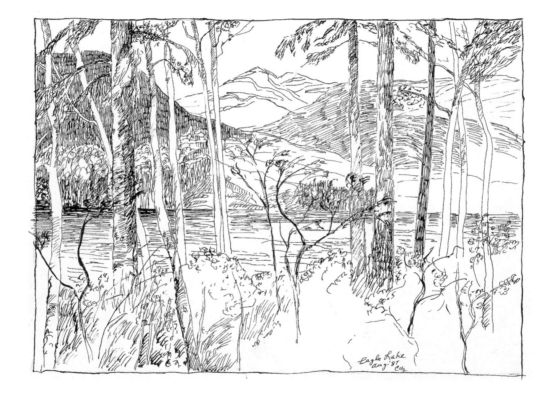

Eagle Lake
1987
Pen and ink on paper
8 ½ x 11 ½ in.
Collection of the artist

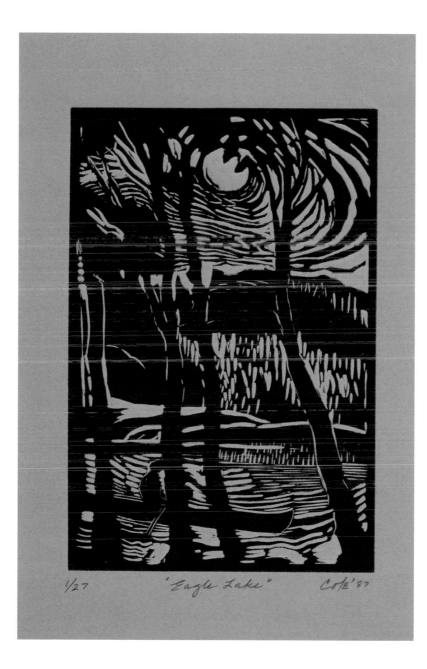

1/27 "Eagle Lake" Cote '87

Eagle Lake
1987
Linoleum block print
9 x 6 in.
Courtesy of the artist and
Lisa Harris Gallery

Eagle Lake (Storm Coming In)
1987
Pen and ink on paper
8 ½ x 11 ½ in.
Collection of the artist

Tatler Lake
1987
Pen and ink on paper
8 ½ x 11 ½ in.
Collection of the artist

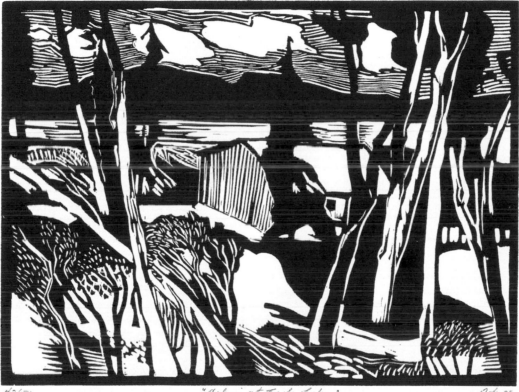

"Cabin at Eagle Lake" Cole 88

42/50

Cabin at Eagle Lake
1988
Linoleum block print
9 x 12 in.
Courtesy of the artist and
Lisa Harris Gallery

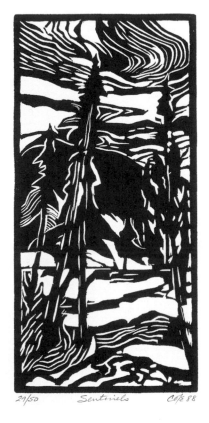

29/50 Sentinels Cole 88

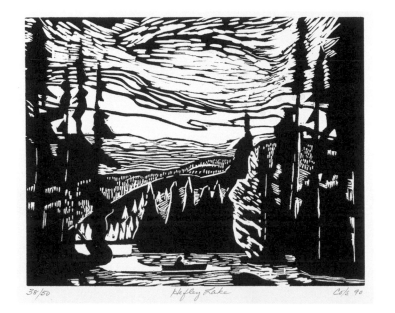

38/50 Hefley Lake Cole 90

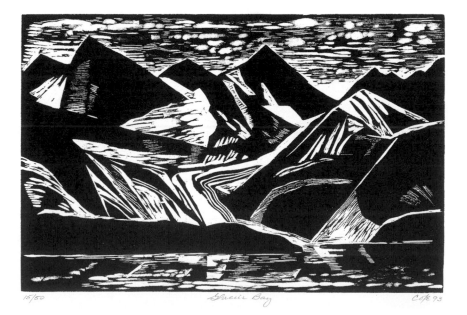

15/50 Glacier Bay Cole 93

(clockwise from above)

Sentinels
1988
Apple woodblock print
10 x 5 in.
Courtesy of the artist and
Lisa Harris Gallery

Hefley Lake
1990
Pear woodblock print
8 x 10 in.
Courtesy of the artist and
Lisa Harris Gallery

Glacier Bay
1993
Birch woodblock print
8 ¾ x 13 ½ in.
Courtesy of the artist and
Lisa Harris Gallery

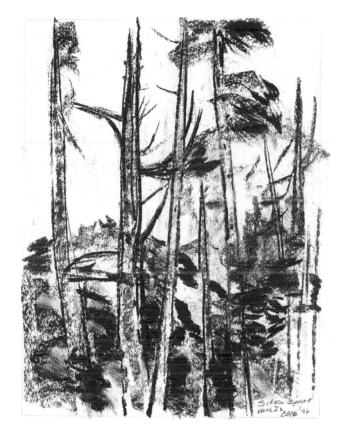

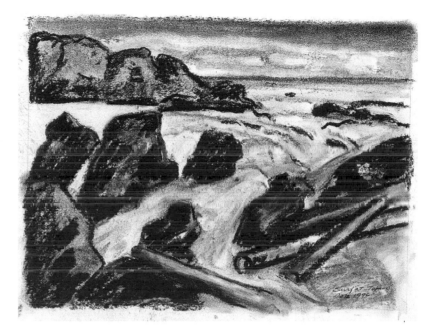

(left)
Sitka Spruce
1996
Charcoal on paper
12 x 9 in.
Collection of the artist

Surf at Tofino
1996
Charcoal on paper
9 x 12 in.
Collection of the artist

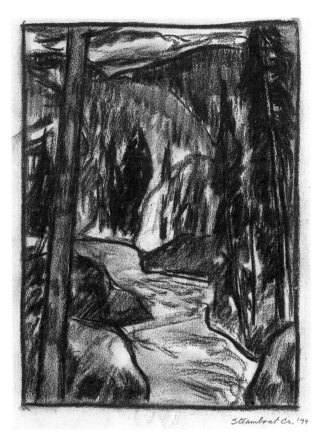

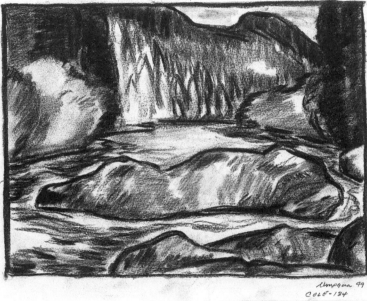

(left)
Steamboat Creek
1999
Charcoal on paper
12 x 9 in.
Collection of the artist

Umpqua River
1999
Charcoal on paper
9 x 12 in.
Collection of the artist

ADDITIONAL WORKS

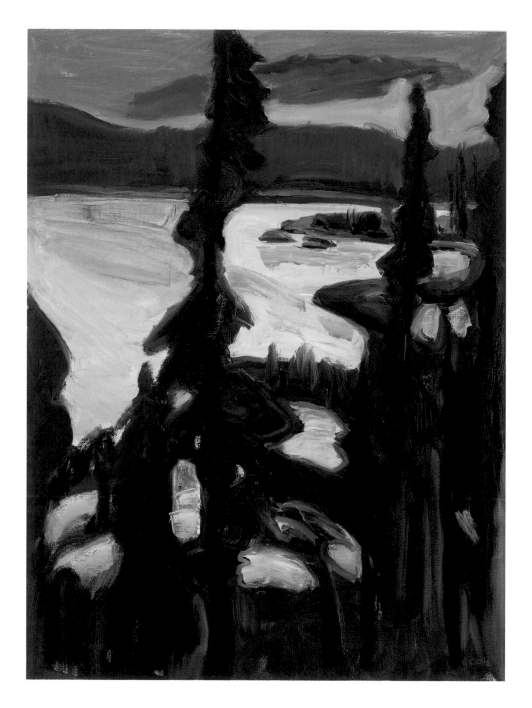

Eagle Lake No. 1
1988
Oil on linen
32 x 24 in.
Collection of John Sisko

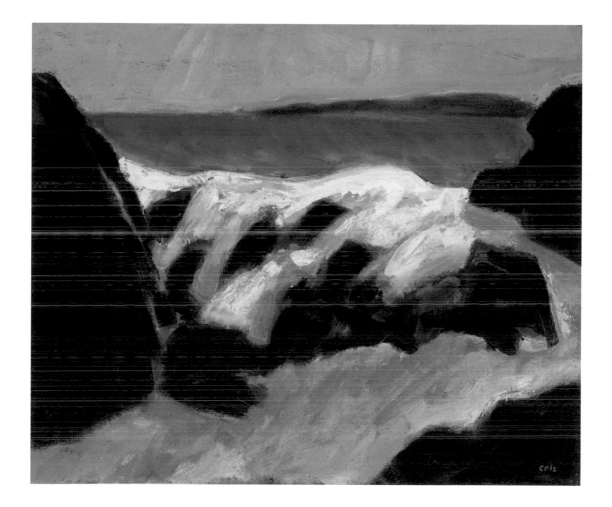

The Wave No. 2
1993
20 x 24 in.
Oil on linen
Collection of Dorothy and
Tom Sherwood

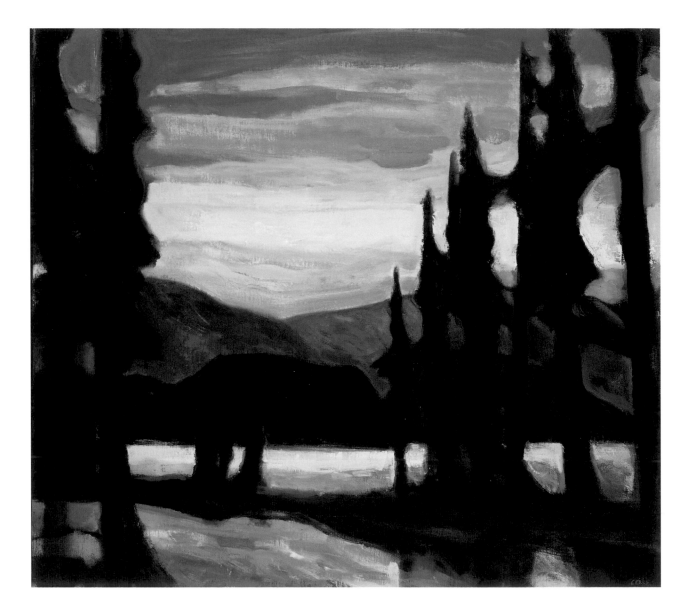

Chilko Lake
1994
Oil on linen
32 x 36 in.
Private collection

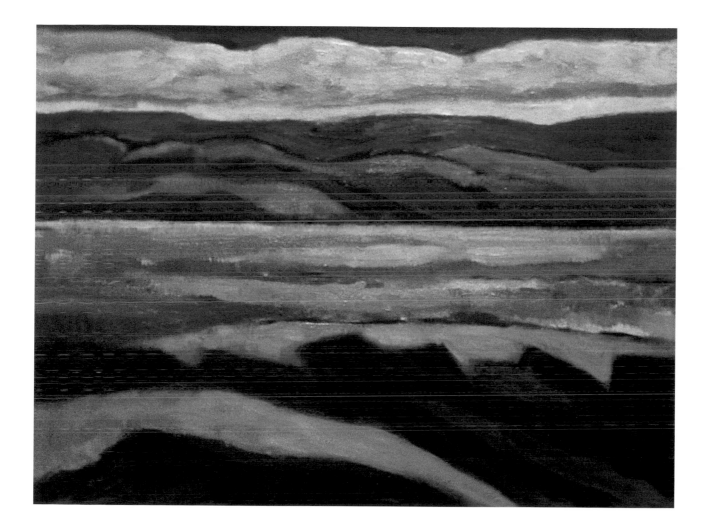

Red Hills, Okanogan
1994
Oil on paper
22 x 30 in.
Private collection

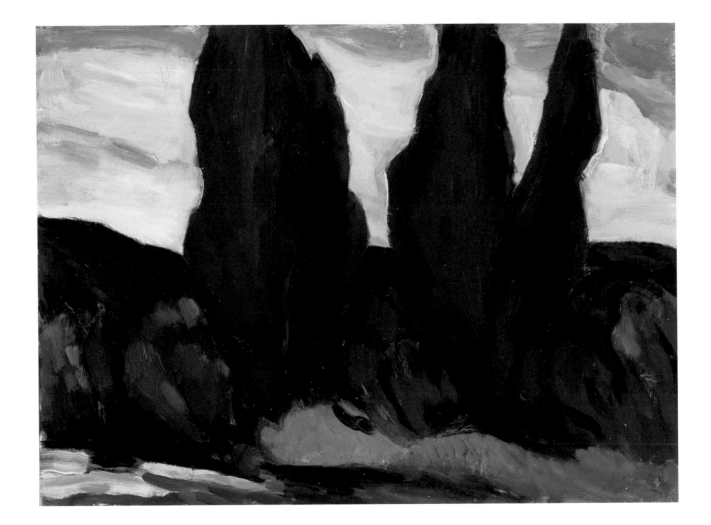

Red Trees
1997
Oil on linen
12 x 16 in.
Collection of Fred Rabel

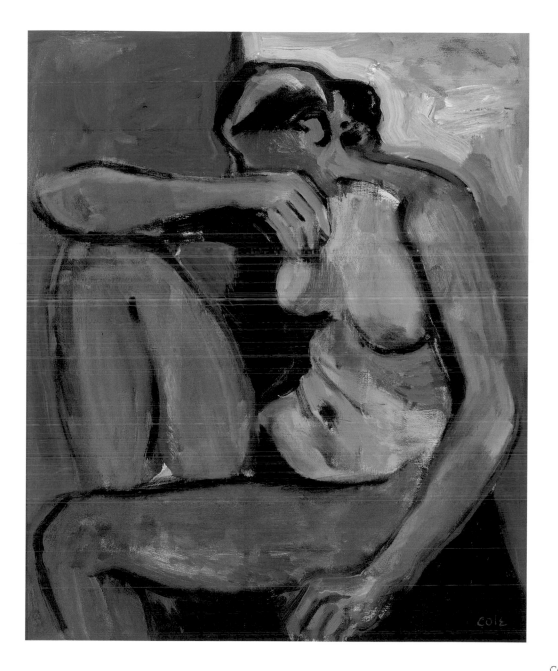

Hyla Seated
1994
Oil on linen
24 x 20 in.
Collection of Ben Feingold

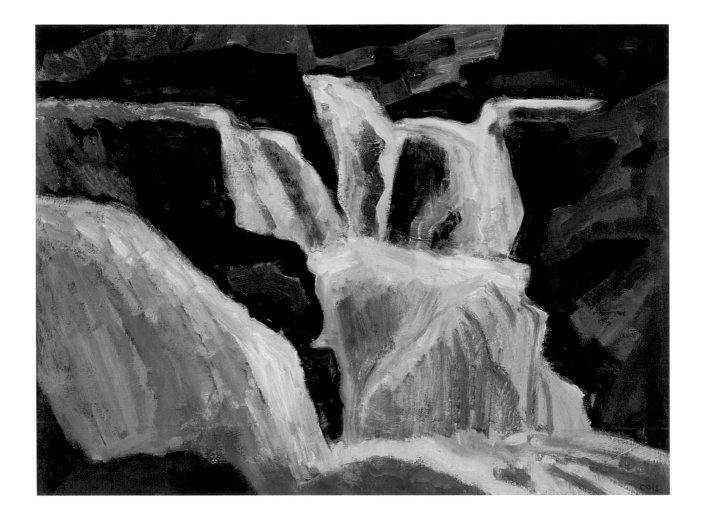

Deadman's Falls
1995
Oil on linen
24 x 32 in.
Private collection

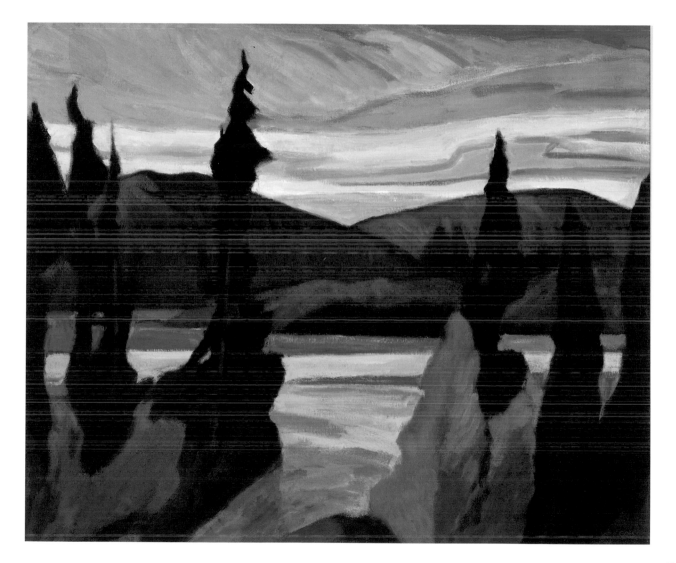

Tatler Lake
1996
Oil on linen
30 x 36 in.
Collection of Lucille Cole

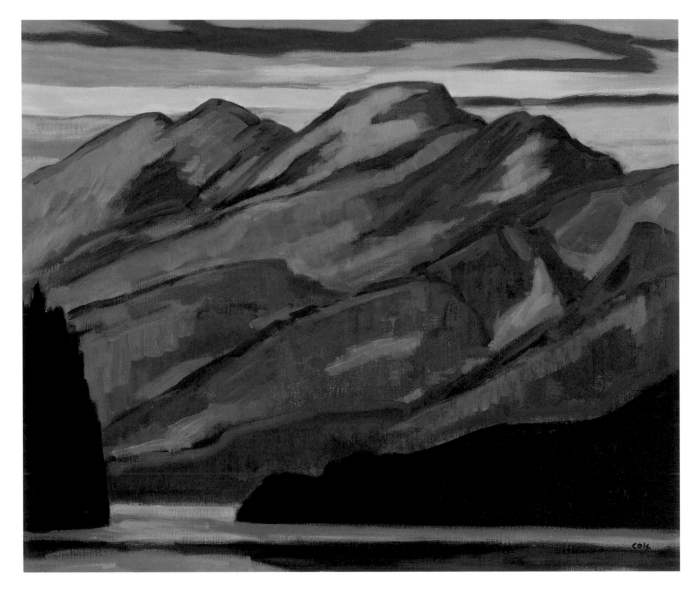

Storm King Mountain
1998
Oil on linen
30 x 36 in.
Collection of the artist

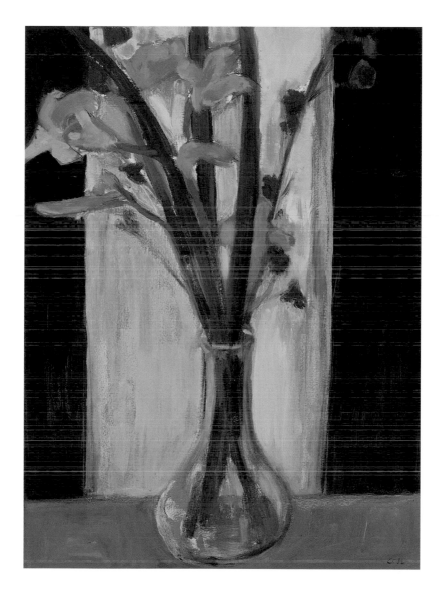

Lilies
1998
Oil on paper
22 x 16 in.
Collection of Jill and
Edward Rosenthal

103

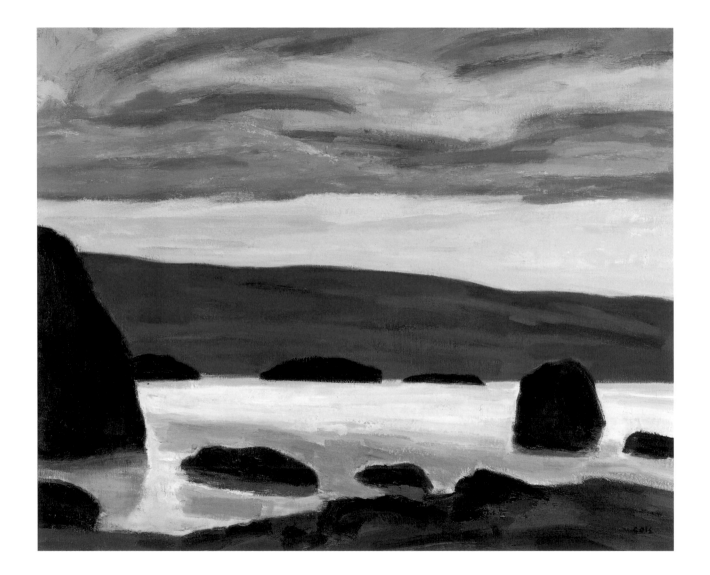

Near Depoe Bay
2000
Oil on linen
36 x 44 in.
Collection of Cecile Thomas

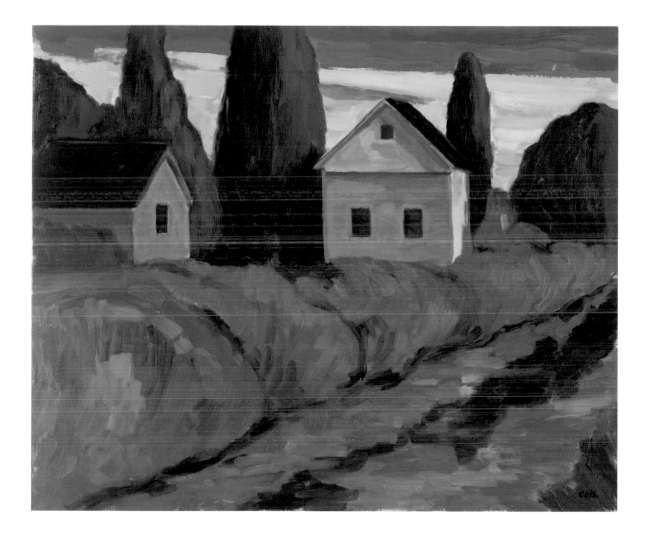

Edison Slough
2002
Oil on linen
20 x 24 in.
Collection of Beverly and
David Taylor

© Mary Randlett

John Cole portraits by
Mary Randlett, 2003

106

JOHN COLE

Born 1936, London, United Kingdom
Resides in Bellingham, Washington

EDUCATION

1962–64 Pasadena City College,
 Pasadena, California
1955–58 Pratt Institute, New York, New York

SOLO EXHIBITIONS

2003 Lisa Harris Gallery, Seattle
 Kinsey Gallery, Seattle University, Seattle

2002 Lisa Harris Gallery, Seattle

2000 Lisa Harris Gallery, Seattle

1999 Lisa Harris Gallery, Seattle

1997 Lisa Harris Gallery, Seattle

1996 Lisa Harris Gallery, Seattle

1994 Lisa Harris Gallery, Seattle

1993 Augen Gallery, Portland

1992 Lisa Harris Gallery, Seattle

1991 Ingvaldsen Gallery, Portland, Oregon
 Lisa Harris Gallery, Seattle

1990 Blue Horse Gallery, Bellingham

1989 Blue Horse Gallery, Bellingham
 Lisa Harris Gallery, Seattle

1988 Blue Horse Gallery, Bellingham

1987 Blue Horse Gallery, Bellingham

1985 Roeder Home Gallery, Bellingham

1984 Chrysalis Gallery, Western Washington
 University, Bellingham

1978 Magnolia Gallery, Bellingham

1974 Chehalis Library Museum,
 Chehalis, Washington

© Mary Randlett

BIOGRAPHY

2002 *The Drawn Image,* Evergreen College, Olympia

2001 Lucia Douglas Gallery, Bellingham

2000 *Whatcom Land Trust Exhibition,* Blue Horse Gallery, Bellingham

Lucia Douglas Gallery, Bellingham

1999 *From Here to Horizon: Artists of the Rural Landscape,* Whatcom Museum of History & Art, Bellingham

1998 Poster commission and benefit exhibition, Evergreen AIDS Foundation, Bellingham

Garden Variety, Lisa Harris Gallery, Seattle

1996 *Utopian Visions,* Port Angeles Fine Art Center, Port Angeles, Washington

Love of the Land, Northwest Building Corporation, Seattle

1994 *Three Northwest Artists,* Lucia Douglas Gallery, Bellingham

Northwest Landscapes, Northwest Building Corporation, Seattle

1992 *Figures,* Blue Horse Gallery, Bellingham

Seattle Invitational: 20 Galleries/20 Artists, Security Pacific Gallery, Seattle

United States Embassy, Lima, Peru (through 1994)

1991 *Northwest Impressions,* Seattle Art Museum Rental/Sales Gallery, Seattle

1990 *The Bellingham School,* Mercer Island Arts Center, Mercer Island, Washington

Small, Lisa Harris Gallery, Seattle

1988 Alonso/Sullivan Gallery, Seattle

Northwest Landscapes, Anacortes Art Gallery, Anacortes, Washington

1987 Whatcom Museum of History & Art, Bellingham

Index Gallery, Clark College, Vancouver, Washington

Jackson Street Gallery, Seattle

1985–86 Northwest International Art Competition, Whatcom Museum of History & Art and Allied Arts, Bellingham

1984 Chrysalis Gallery, Western Washington University, Bellingham

1975 Frye Art Museum, Seattle

Northwest Artists, Washington State Capitol Museum, Olympia

Portland Art Museum, Portland

1974 *All West Art Show,* Ocean Shores, Washington

Northwest Artists, Washington State Capitol Museum, Olympia

Northwest Artists, Tacoma Art Museum, Tacoma

1973 Chehalis Library Gallery, Chehalis, Washington

Bank of Hawaii, Honolulu

Brett & Daugert Law Firm, Bellingham

Cisco Systems, Seattle

Commerce Bank, Seattle

Dorsey & Whitney LLP, Seattle

GNA, Seattle

Hagens & Berman, Seattle

Merrill Lynch, Seattle

Royal Danish Consulate, Portland

Trillium Corporation, Bellingham

Sirach Capital Management, Seattle

WRQ, Seattle

Washington Mutual Bank, Seattle

SELECTED BIBLIOGRAPHY

Fahey, Anna. "SW Spotlight." *Seattle Weekly,* 21 December 2000.

Farr, Sheila. "Three Exhibits." *Bellingham Herald,* 20 October 1992.

The Fine Art Index. North American ed. Chicago: International Art Reference, 1992.

Harmon, Kitty. *The Pacific Northwest Landscape—A Painted History.* Seattle: Sasquatch Books, 2001.

Harris, John. "He Weaves Landscapes from Paint." *Bellingham Herald,* 7 September 1989.

New American Paintings: A Quarterly Art Exhibition. Needham, Mass: Open Studio Press, 1997.

ALASKA

Alaska No. 6 (Scene from Glacier Bay)
1997
Oil on linen
24 x 28 in.
Collection of Lucille Cole

Alaska Night
1997
Oil on linen
30 x 36 in.
Private collection

Glacier
1997
Oil on linen
24 x 28 in.
Collection of Heidi and Mark Craemer

Glacier Bay
1997
Oil on linen
28 x 48 in.
Collection of Bard and Julie Richmond

CHILCOTIN

Morice River
1986
Acrylic on paper
14 x 19 in.
Collection of Lucille Cole

Cabin at the Lake
1989
Oil on linen
36 x 48 in.
Private collection

Red Trees
1994
Oil on linen
30 x 36 in.
Collection of Lynne Wandrey

Chilko
1998
Oil on linen
36 x 90 in.
Collection of Nancy Packard and Gary Rosen

Tatler Lake
1998
Oil on linen
28 x 70 in.
Collection of Millie Livingston

Eagle Lake
2000
Oil on linen
24 x 30 in.
Collection of Jill and Edward Rosenthal

DESCHUTES RIVER

Metholius River
1985
Oil on linen
24 x 30 in.
Collection of Brett & Daugert Law Firm

Sherars Falls
1991
Oil on paper
16 x 20 in.
Collection of Anita Baker

Whitehorse Canyon
1991
Acrylic on paper
20 x 24 in.
Private collection

Autumn Gold
1992
Oil on paper
8 x 10 in.
Collection of Theresa Slechta

Waterfall
1997
Oil on linen
24 x 34 in.
Collection of Cathy Gilbert

Sherars Falls
1999
Oil on linen
50 x 120 in.
Collection of Brad Lovering and Valarie Baker

WESTERN WASHINGTON

Along the Cedar River
1969
Oil on canvas
18 x 24 in.
Collection of Lucille Cole

Toutle River Landscape
1980
Oil on paper on board
18 x 24 in.
Collection of Thomas Wood

Hovander Lake Sunset
1987
Oil on linen
24 x 30 in.
Collection of Dorothy and Tom Sherwood

Terrell Lake Winter
1987
Oil on linen
18 x 24 in.
Collection of Dorothy and Tom Sherwood

View from Chuckanut
1989
Oil on paper on board
16 x 12 in.
Collection of John Sisko

Illinois Street
1991
Oil on paper
16 x 20 in.
Collection of Marie Doyle and Robert Ingman

Northwest Evening
1991
Oil on linen
36 x 48 in.
Collection of Linn Gould and Timothy Summers

Autumn
1997
Oil on linen
30 x 36 in.
Collection of Larry Holder

Bay of Mystery
1997
Oil on linen
36 x 48 in.
Collection of David Groff and Roslyn Solomon

Along the Nooksack
1998
Oil on linen
20 x 24 in.
Collection of Brad Lovering and Valarie Baker

By the Pond
2001
Oil on linen
16 x 20 in.
Collection of Brad Lovering and Valarie Baker

Clark's Point
2001
Oil on linen
22 x 28 in.
Collection of Mary and Albert Froderberg

EXHIBITION CHECKLIST

Evening Light
2001
Oil on linen
16 x 20 in.
Collection of Tom and
Tamsyn Marie Palmesano

Madronas
2002
Oil on linen
48 x 60 in.
Collection of Millie
Livingston

Skagit Valley Scene
2001
Oil on linen
16 x 20 in.
Collection of Dorsey &
Whitney LLP

Wild Fruit Trees
2001
Oil on board
16 x 20 in.
Collection of Stephen Nute

OKANOGAN

Bend in the River
1985
14 x 19 in.
Acrylic on paper
Collection of Stephen Nute

Trees at Gusterson Lake
1985
Acrylic on paper
19 x 14 in.
Collection of Lucille Cole

*Trees on Biscuit Ridge,
Walla Walla*
1990
Oil on linen
20 x 16 in.
Collection of John Sisko

Mysterious Lake
1995
Pastel on paper
20 x 28 ½ in.
Collection of Charles and
Susan Pearson

UMPQUA RIVER

Waterfall No. 8
1992
Oil on linen
80 x 50 in.
Collection of Al and Lisa
Van Kampen

Fall–Umpqua River
1995
Oil on linen
16 x 13 in.
Collection of Dr. and Mrs.
Bruce Blasberg

Fall, Umpqua River
1997
Oil on linen
36 x 44 in.
Collection of Eric Olanie

Little Falls No. 2
1998
Oil on linen
30 x 36 in.
Collection of David and
Virginia Ridgway

The Rower
1998
Oil on linen
36 x 48 in.
Collection of David Groff
and Roslyn Solomon

Steamboat Creek
1998
Oil on canvas
30 x 36 in.
Collection of Eric Peterson
and Barbara Pomeroy

Waterfall
1998
Oil on linen
48 x 60 in.
Private collection

Bend in the River
2000
Oil on linen
24 x 32 in.
Collection of Brad Lovering
and Valarie Baker

Little Falls No. 3
2000
Oil on linen
15 x 30 in.
Collection of Lisa Harris
and David Wendel

North Umpqua Creek
2000
Oil on linen
13 x 16 in.
Collection of Stephen Nute

Waterfall
2002
Oil on linen
48 x 36 in.
Courtesy of the artist and
Lisa Harris Gallery

VANCOUVER
ISLAND

Beach Rocks
1992
Oil on paper
16 x 20 in.
Collection of James and
Karen Solimano

Phillips Creek
1992
Oil on paper
24 x 16 in.
Collection of the artist

Sitka Spruce
1992
Oil on canvas
60 x 46 in.
Collection of the
Behnke Family

*Anatomy of a Waterfall
No. 2*
1994
Pastel on paper
22 x 16 in.
Collection of the artist

Genesis No. 5
1995
Oil on linen
42 x 68 in.
Private collection

*The Dance (By the
Waterfall)*
1995
Pastel on paper
22 x 16 in.
Courtesy of the artist and
Lisa Harris Gallery

Buttle Lake
1997
Oil on linen
24 x 30 in.
Collection of Marc and M.
Leigh Barreca

Myra Falls No. 10
1998
Oil on linen
16 x 20 in.
Collection of Michele
Radosevich

PRINTS AND
DRAWINGS

Aspens at Eagle Lake
1987
Pen and ink on paper
11 ½ x 8 ½ in.
Collection of the artist

Cabin at Eagle Lake
1987
Pen and ink on paper
8 x 9 in.
Collection of the artist

Eagle Lake
1987
Pen and ink on paper
8 ½ x 11 ½ in.
Collection of the artist

Eagle Lake
1987
Linoleum block print
9 x 6 in.
Courtesy of the artist and
Lisa Harris Gallery

*Eagle Lake (Storm
Coming In)*
1987
Pen and ink on paper
8 ½ x 11 ½ in.
Collection of the artist

Tatler Lake
1987
Pen and ink on paper
8 ½ x 11 ½ in.
Collection of the artist

Cabin at Eagle Lake
1988
Linoleum block print
9 x 12 in.
Courtesy of the artist and
Lisa Harris Gallery

Sentinels
1988
Apple woodblock print
10 x 5 in.
Courtesy of the artist and
Lisa Harris Gallery

Hefley Lake
1990
Pear woodblock print
8 x 10 in.
Courtesy of the artist and
Lisa Harris Gallery

Glacier Bay
1993
Birch woodblock print
8 ¾ x 13 ½ in.
Courtesy of the artist and
Lisa Harris Gallery

Sitka Spruce
1996
Charcoal on paper
12 x 9 in.
Collection of the artist

Surf at Tofino
1996
Charcoal on paper
9 x 12 in.
Collection of the artist

Steamboat Creek
1999
Charcoal on paper
12 x 9 in.
Collection of the artist

Umpqua River
1999
Charcoal on paper
9 x 12 in.
Collection of the artist

WHATCOM MUSEUM OF HISTORY & ART

Administrative	Thomas A. Livesay, Director
	Shirley Schroeder, Executive Administrative Assistant
Accounting	Judy Frost, Accounting Technician
Collections	Janis Olson, Curator of Collections
	Nancy Deasy, Museum Assistant
Development	Kathleen Iwersen, Development Associate
	Tamara Tiegoning, Membership Coordinator
Education	Richard Vanderway, Curator of Education and Public Programs
	Mary Jo Maute, Education Assistant, Volunteer Interpreter Coordinator
Exhibits	Scott Wallin, Exhibits Chief
	Lisa A. Van Doren, Curator of Art
	Curt Mahle, Exhibitions and Facilities Assistant
Facilities	Patrick Dowling, Facilities Manager
	Nancy Grinstead, Custodian
	Glenda Albert, Security Information Attendant
	Adam Jackman, Security Information Attendant
	Katharine Jacobson, Security Information Attendant
	Todd Warger, Security Information Attendant
	Neil Weber, Security Information Attendant
Photo Archives	Toni Nagel, Photo Archivist, Curator of History
	Jeff Jewell, Photo Historian, Archival Technician
Public Relations	Annette Bagley, Public Relations Consultant
	Deanna Zipp, Secretary
Whatcom Children's Museum	Bev Wiltshire, Whatcom Children's Museum Operations Manager
	Susie Burnett, Whatcom Children's Museum Education Coordinator
	Marion Crew, Attendant
	Trischa Farrer, Attendant
	Christie Goss, Attendant
	Aleda Rabel, Attendant
	Seth Spangler, Attendant
	Betsy Stalter, Attendant
	Noah Wass, Attendant

CATALOGUE UNDERWRITERS

Brad Lovering and Valarie Baker
Lisa Harris Gallery
Lucille Cole
The G.R. Plume Company

CATALOGUE SPONSORS

John and Shari Behnke
Haig and Hamida Bosmaijan
Renata E. Cathou
Hank and Lisa Florence
Karie Friedman
Mary and Albert Froderberg
Larry and Barbara Greenfield
David Groff and Roslyn Solomon
Jay Haglund
Vivian and T.C. Hall
Dr. Irene J. Hartzell
Cherie and Mitch Hill
Ann Hungar
Robert Ingman and Marie Doyle
Laura and David Neri
Gloria Pfeif
Fredric Rabel
Michele Radosevich
David and Virginia Ridgway
Jill and Edward Rosenthal
Tom and Dorothy Sherwood
James and Karen Solimano
David and Beverly Taylor
Cecile Thomas
Janet Van Wieringen
Steven Wilson
Thomas Wood and Pamela Brownell
Andrew York

EXHIBITION SPONSORS

Steve Brinn
Phyllis & Charles Self Fund of the Whatcom Community Foundation

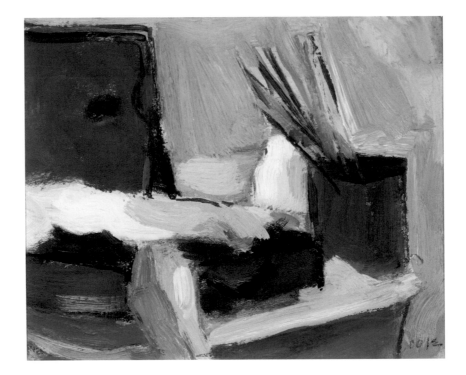

Cole